SHOJO FASHION
Manga Art School, Boys

Irene Flores and Krisanne McSpadden

IMPACT
CINCINNATI, OHIO
www.impact-books.com

CONTENTS

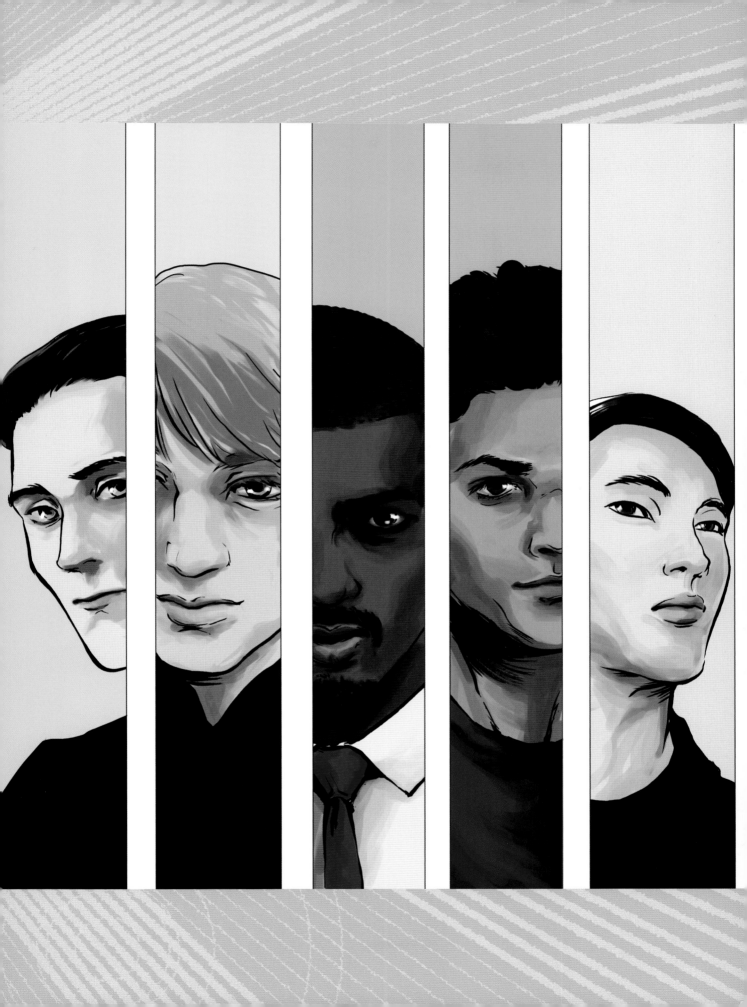

1 | Tools & Techniques

Every artist has their favorite tools and special techniques they've picked up over the years. If you've been drawing for a while, you probably have your own favorites already. Here, we'll cover some basics, in case you find it handy to try them out and add to your bag of tricks. Or, if you are just getting started, this chapter will give you an idea of what you will need to pick up.

Tools

The tools covered here aren't all absolutely necessary. As long as you have a pencil and paper, you can draw. But these tools will help make the process of drawing manga characters easier and faster.

PENCILS
Mechanical pencils work well for all of the exercises covered in this book, and you don't have to bother sharpening them.

LEAD
It is a good idea to keep your pencils filled with blue lead. This makes it easier to go over sketches with darker graphite or ink later. Blue lead also tends to disappear when it is scanned, leaving the darker pencil or ink lines without having to erase all of the preliminary sketching.

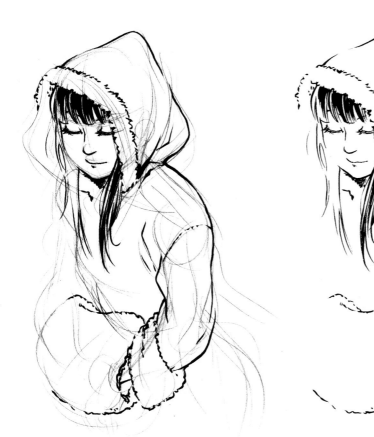

BEFORE AND AFTER
The image on the left shows the preliminary inks over the blue sketch. On the right, the same image was scanned using the black-and-white setting. The blue lines in the sketch have disappeared.

BRUSH PENS

A brush pen is a good choice for a main pen. It gives varying line weight without having to go over the same spot numerous times.

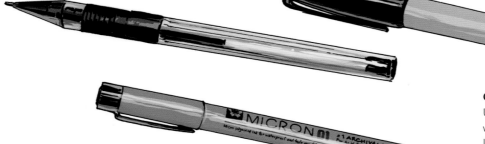

GEL AND FELT-TIP PENS

Use gel pens and felt-tip pens when you have to do straight lines or fill in large spaces. (Suing a brush pen with a ruler can get messy and doesn't always work very well.)

PAPER

You don't need fancy, expensive paper to draw. Whether it's printer paper, thick bristol paper or poster board—if it holds lead and ink, it's good. However, some paper will work better with the tools you prefer. Experiment to see what works best for you. I like Deleter's Plain B paper because my brush pens don't bleed as much, and ink dries very fast.

DIGITAL TOOLS

Take reference shots with a camera phone or use a tablet to speed up your production time by cleaning up and coloring your art digitally. (I use Adobe Photoshop® and a tablet for this.) It's not "cheating" because it will not make you draw better automatically. Just like, pens, paints and other traditional media, digital tools are just that—tools to help you with your art.

Light & Color

The color, intensity and placement of lighting can dramatically change the look and the feeling of your characters and the scene as a whole. Let's examine the same face in several types of lighting to see how changing the lighting changes the way we read someone's features.

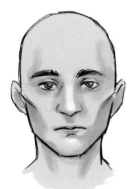

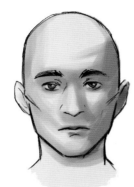

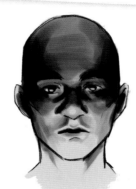

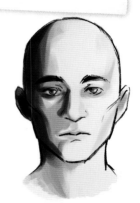

BRIGHT DAYLIGHT

A few shadows highlight the contours of the face in bright daylight.

SUNSET

The light from the sun isn't very intense at sunset, but it spreads over a wide area. The light source comes from the left and has an orange tone. The shadows on the face are softer and not very deep.

CELL PHONE

The light source is blue-green and comes from below. It is small but less intense than neon lighting, leaving lots of shadows.

NEON LIGHT FROM THE RIGHT

This type of light comes from a smaller, concentrated source that doesn't create much reflective lighting. The shadows are harsher and the planes of the face are highlighted by light and washed out.

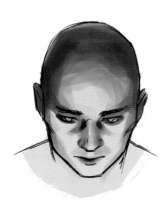

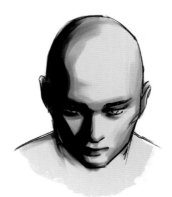

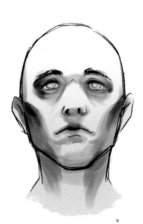

CAMPFIRE

The light source comes from the fire directly below.

LOW FLUORESCENT LIGHT FROM THE RIGHT

Changing the angel of the head will change how light highlights and shadows certain features. This can be done with various light sources to intensify a mood.

THE LIGHT OF JUDGMENT

The light source is a harsh glaring light from above.

Shadow

How you light a picture tells a story all on its own! Here's an example of the exact same line art becoming two pieces that imply a very different mood based entirely on how you place the lighting.

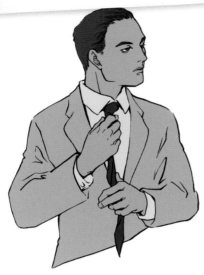

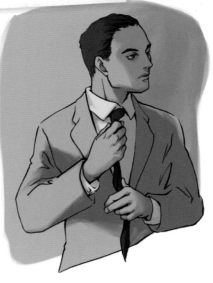

FLAT COLOR
The preliminary image has flat colors, and no additional lighting or shadow has been applied.

DEEPENED SHADOWS
The shadows on the right were deepened with a desaturated blue-violet. This puts the face and front of the character in shadow, and immediately makes him look like a bit of a shady character.

CHANGED LIGHT DIRECTION
A light layer of desatured green shadows is added and the light source is placed on the left. It looks like he is perhaps standing in his office with the lights off, lit by fluorescent lights filtering in from the hallway. Important finishing touches include a highlight in the eye and lightening along his brow from reflected light. This gives a three-dimensional look.

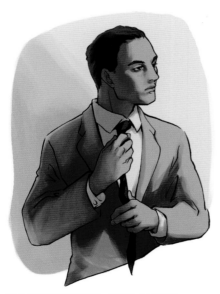

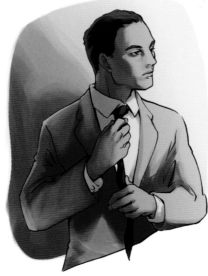

BACKGROUND AND LIGHT
Here we have the same character with the original flat colors, but the taupe background has a bit of yellow added in to lighten it up. The light source is on the right, so his face and front are lit up.

COLOR AND HIGHLIGHTS
A rich bright purple was used to create his shadow on the wall. A stronger yellow-orange was used to highlight his face. Now it looks like he's loosening his tie at the end of a long workday.

Draping Fabric

Everyone knows fabrics flutter in the wind on a blustery day. But it can be easy to forget that fabric is lying over a body, and is often changing to reflect the form and movement of the body underneath. Make sure to account for this in your drawing to provide clarity and emphasis of movement.

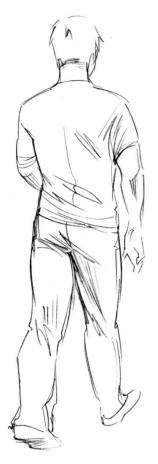

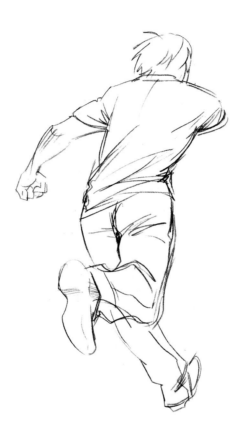

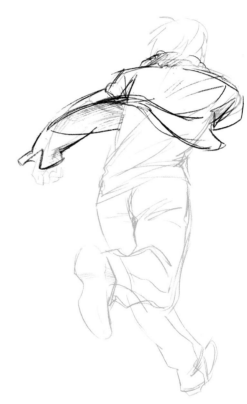

WALKING
When making shallow motions such as walking, fabric movement is less dramatic. Direct the fabric in the proper direction, such as where the lines on the thigh convey which leg is pulling forward.

RUNNING
The body motion of a figure running dramatically engages both the arms and legs. When running, the pants have sharp horizontal folds where the fabric is bent to accommodate the body. The shirt pulls up in the direction of the shoulder that swings forward. The hemline lifts forward in the same direction in response to the arm moving.

BLOWING JACKET
Clingy T-shirt material won't move in the wind much. But if wearing a jacket, the hemline lifts just below the arms and gives the runner a stronger sense of speed.

COLOR A SCENE AT NIGHT

Follow the steps to learn how to color a scene at night and see how your color choices can completely change the time of day in your scene.

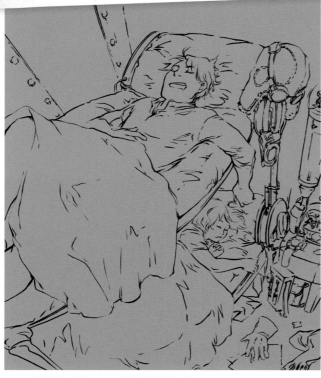

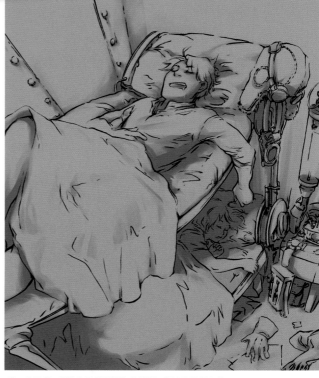

1 LAY IN THE BACKGROUND
It's night and they're asleep, so a desaturated blue-gray background is laid in behind the lineart.

2 ADD SHADOWS AND SHADING
Since there are so many elements to this piece, all shading is done in monochrome blue. This way, the underlying shadow colors will be consistent throughout the picture. The light source is coming from above, but diffused through a window so the shadows are soft.

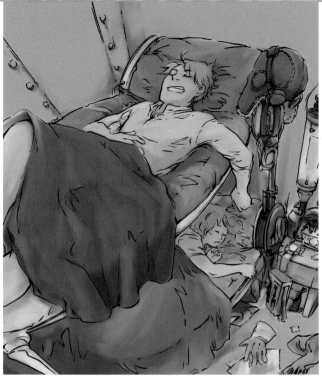

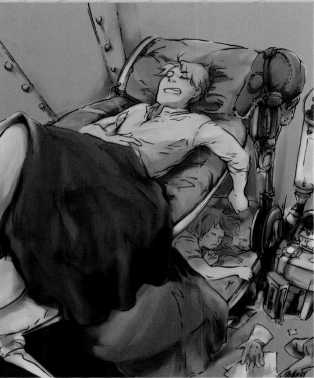

3 ADD COLOR

Because of the lack of light, spots of color are added using a fairly desaturated palette. Notice that the shadows we put in before add the necessary dimension to mostly flat coloring. If you wanted to keep this a sleeping-at-night piece, you would darken the established shadows, but that's not the direction we want to go.

4 BUILD UP THE LIGHT SOURCE

A yellow-orange glow is added to the light source above the boys' bunk bed and to the viewer's left. The drawing was started in blues so that when adding the yellow-orange at this stage it will be almost like shining the rising sun into the picture. It also gives it a bit of a sepia-tone, which we want.

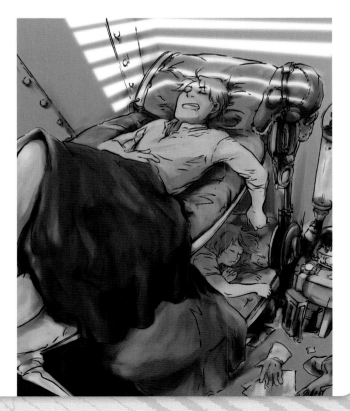

5 ADD FINAL DETAILS

The boys have slept in! The final detail to sell the look of the sun shining in is to create cutouts where the light filters in through the window slats. Don't forget that the light bends at the corner of the wall, and gets distorted on objects like the pillow, face and aviator hat.

2 | Drawing Bodies

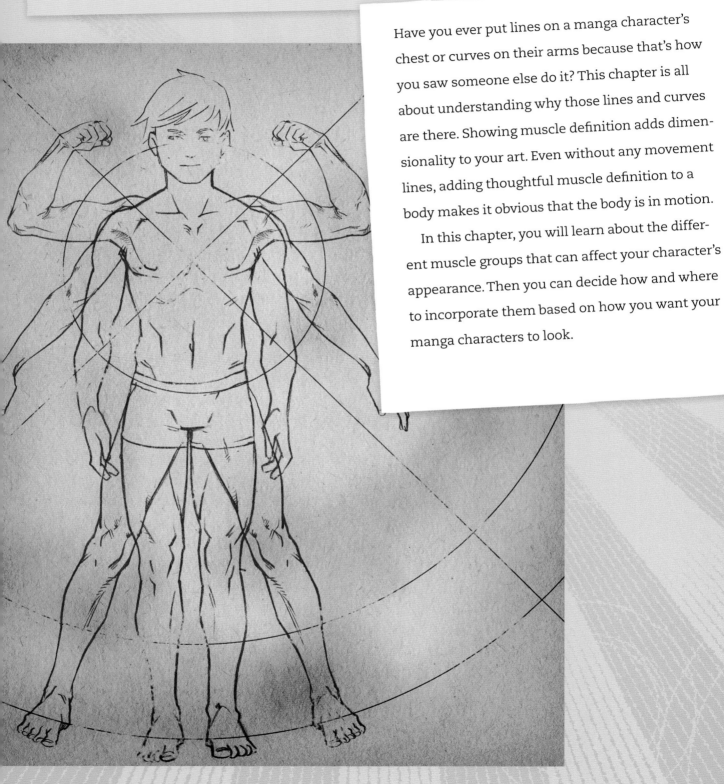

Have you ever put lines on a manga character's chest or curves on their arms because that's how you saw someone else do it? This chapter is all about understanding why those lines and curves are there. Showing muscle definition adds dimensionality to your art. Even without any movement lines, adding thoughtful muscle definition to a body makes it obvious that the body is in motion.

In this chapter, you will learn about the different muscle groups that can affect your character's appearance. Then you can decide how and where to incorporate them based on how you want your manga characters to look.

The Difference Between Guys and Girls

First, let's look at an overview of the human body. Obviously not everyone looks like this, and even the differences between male and female bodies are at best, a generalization. However, it's important to have a basic understanding of all the body parts in proportion to one another right from the beginning.

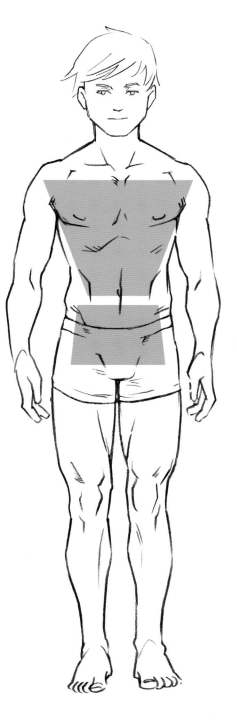

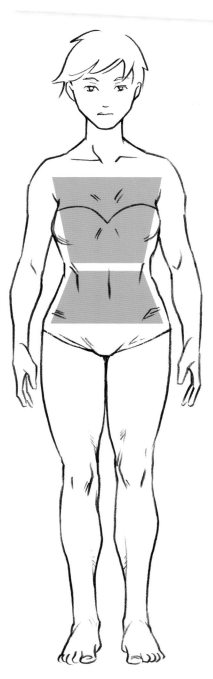

MALE-FEMALE COMPARISON
Men tend to have straighter hips and wider shoulders, while women tend to have narrower waists with hips around the same width as the shoulders. Think of this as only a very general guideline though, since people's bodies come in many shapes and sizes.

The Neck

Here are some examples of necks and how they move and connect to the head and shoulders in various poses. Practice drawing these and other poses like them to get an idea of the range of movement in the neck and how it looks when turned from different angles. Try to practice showing off the prominent muscles and bones without using too many lines.

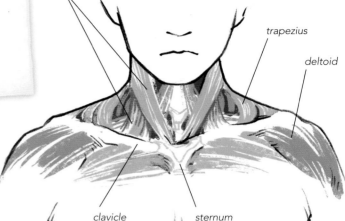

sternocleidomastoid

trapezius

deltoid

clavicle

sternum

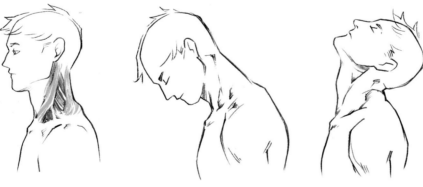

OVERVIEW
This simple example shows how the neck muscles appear on the body.

MAJOR NECK MUSCLES
The muscles and bones labeled are those that show the most definition on the body. The clavicle and sternum will be less visible on heavier characters. The trapezius and deltoid will be larger on characters that use a lot of upper body strength. The sternocleidomastoid is most visible when someone is stretching their neck.

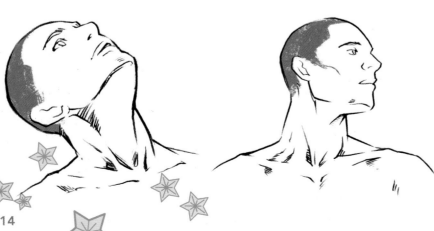

STRETCHED AND BENT POSES
Here the neck is shown in profile and when stretched at various angles. Note that without lowering the jaw, someone's chin won't touch their chest. And when the head is tilted back, the neck does not make a straight line.

The Torso

Now let's look at the torso and the different muscle groups in that area of the body. Everyone will have these muscles in varying sizes depending on how often they work them out.

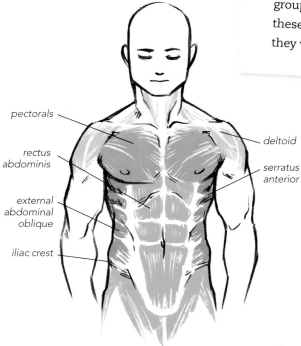

pectorals

deltoid

rectus abdominis

serratus anterior

external abdominal oblique

iliac crest

TORSO MUSCLE PLACEMENT

The abs, or rectus abdominis, sit on the front of the torso. The serratus anterior, which are often mistaken for the rib cage, are actually ribbons of muscle that run out from the ribs.

SKETCHING MUSCLE STRUCTURE

Start with a rough torso sketch to get the basic proportions where you want them. Then by drawing on top of that, you can easily change the same shape to male or female, muscular or flabby as it suits you.

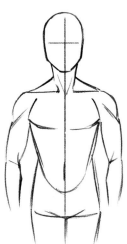
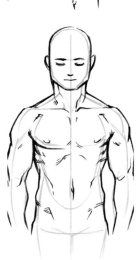
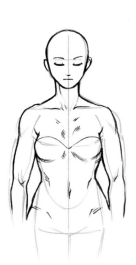

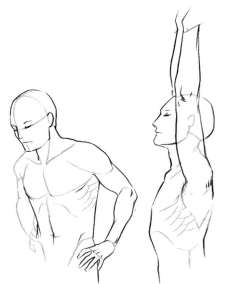

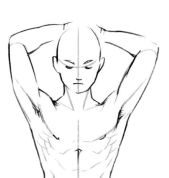

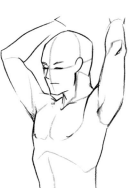

CONSIDER HOW MUSCLES AFFECT MOVEMENT

When you draw bodies in various positions, think about where the muscle groups are and what they are doing. Muscles are what allow the body to move, so they should be stretching and bending along with your character.

Torso Styles

Here are some ways you can vary the style and pose of a torso to change the look, emotions and personality of your manga characters.

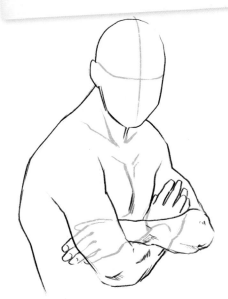

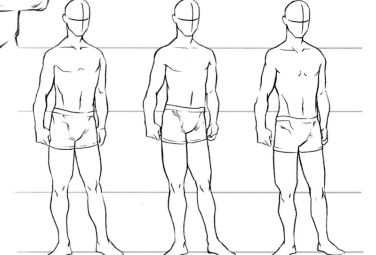

LEAN MUSCLES

This is the same guy, but with his arms lifted up. He looks lean in this pose because his muscles are all being stretched upward.

FRAMEWORK FIRST

Draw your framework first, then add muscle mass to it. That way you won't accidentally mess up your skeletal proportions when drawing different body types.

EXAGGERATED MUSCLES

Very few people have this kind of muscle mass, but an exaggerated look can help you get an idea of what the various muscle groups look like on a body.

SKINNY VS. MUSCULAR

Naturally, muscles get bigger when they contract. You can really tell the difference between a skinny person and a muscular person when they have their arms crossed like this.

CONSIDER PROPORTIONS

These three figures are all the same height, but they have different torso lengths. This affects arm and leg proportions, so try to keep all of this in mind when designing your characters.

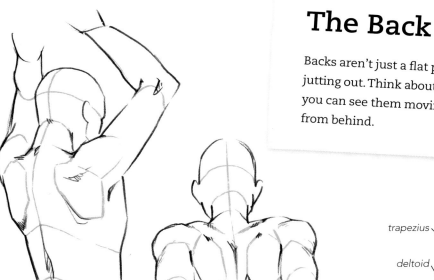

The Back

Backs aren't just a flat plane with some shoulder blades jutting out. Think about the muscle groups and how you can see them moving when viewing a character from behind.

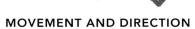

trapezius

deltoid

scapula

latissimus dorsi

external abdominal oblique

iliac crest

FRAMEWORK OF THE BACK
These examples show the main framework of the back. Note that the spine and shoulder blades are the most prominent lines on the back.

MOVEMENT AND DIRECTION
Notice how the muscles on the right side of the back change direction to accommodate the right arm stretching upward.

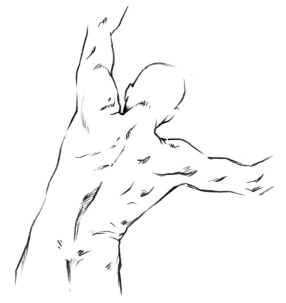

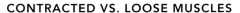

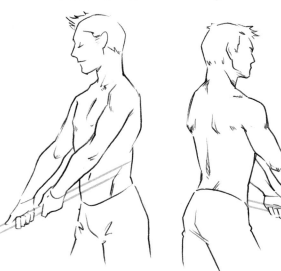

CONTRACTED VS. LOOSE MUSCLES
Remember, muscles are more defined when they're contracted. Compare the right side to the left on this figure at it leans to the right.

PAY ATTENTION TO ANGLE
Keep track of what the body is doing from all angles. You should be able to turn the pose around and still keep the limbs correctly spaced in relation to the rest of the body.

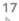

Arms

Don't be content with formless, noodle arms! Here's where all the muscles go that give arms their shape.

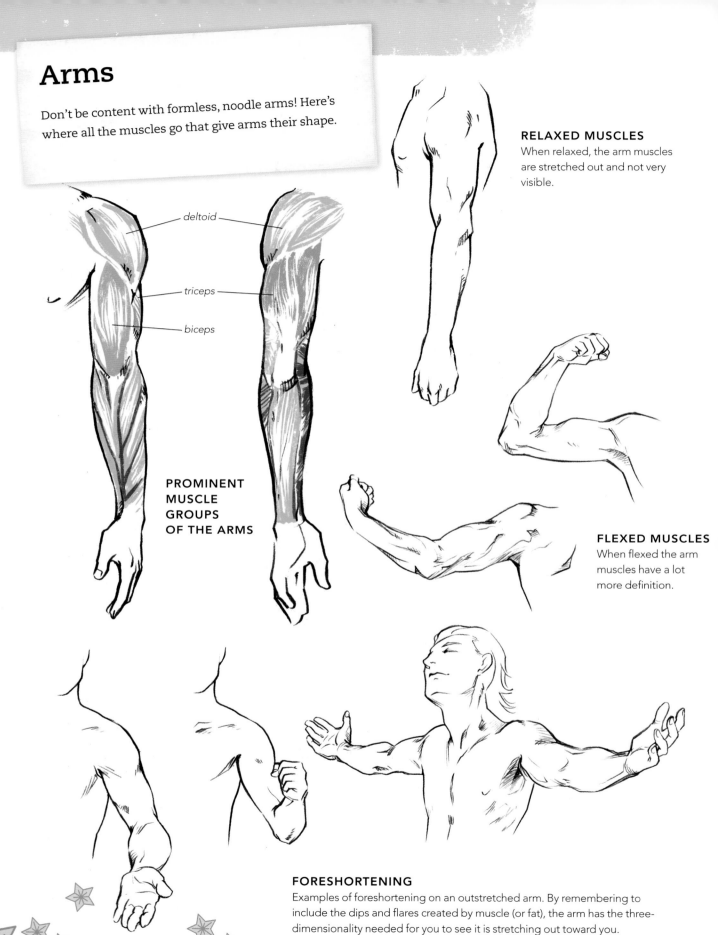

deltoid

triceps

biceps

PROMINENT MUSCLE GROUPS OF THE ARMS

RELAXED MUSCLES
When relaxed, the arm muscles are stretched out and not very visible.

FLEXED MUSCLES
When flexed the arm muscles have a lot more definition.

FORESHORTENING
Examples of foreshortening on an outstretched arm. By remembering to include the dips and flares created by muscle (or fat), the arm has the three-dimensionality needed for you to see it is stretching out toward you.

Hands

Hands are a challenge. The only real secret to drawing hands is to draw lots and lots and lots of hands. This will get you started.

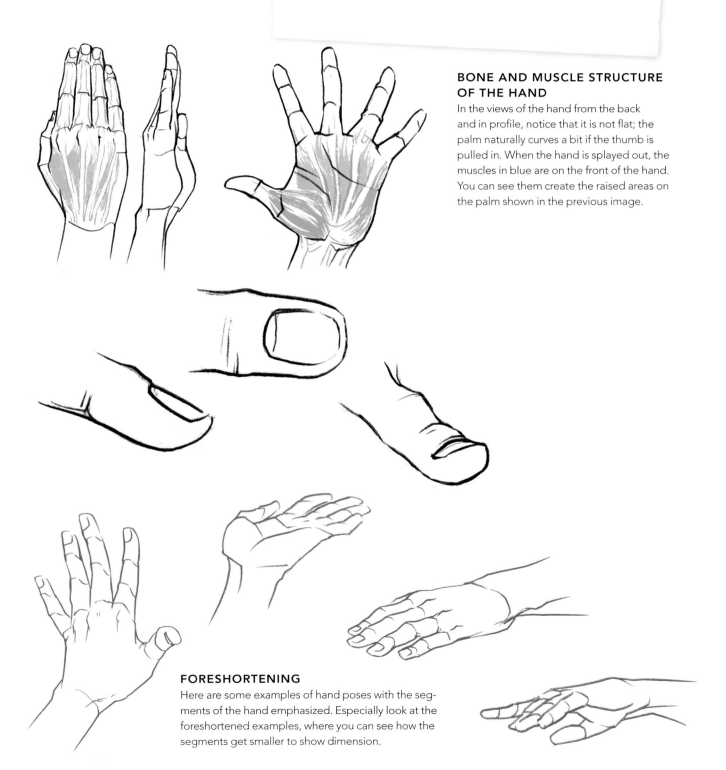

BONE AND MUSCLE STRUCTURE OF THE HAND

In the views of the hand from the back and in profile, notice that it is not flat; the palm naturally curves a bit if the thumb is pulled in. When the hand is splayed out, the muscles in blue are on the front of the hand. You can see them create the raised areas on the palm shown in the previous image.

FORESHORTENING

Here are some examples of hand poses with the segments of the hand emphasized. Especially look at the foreshortened examples, where you can see how the segments get smaller to show dimension.

More Hands

Here we have lots and lots of hands, seen in different positions and from different angles. The hands in red segment the fingers out so you can see exactly where they should be bending. Practice your hand drawing skills by drawing the ones on this page from a new angle. And draw out the segments first so you get used to thinking about the way the hand is put together.

Hands In Action

Here are some examples of hands interacting with each other and other objects. When drawing hands in action, draw through your object so that positioning and proportion of the hand stays consistent.

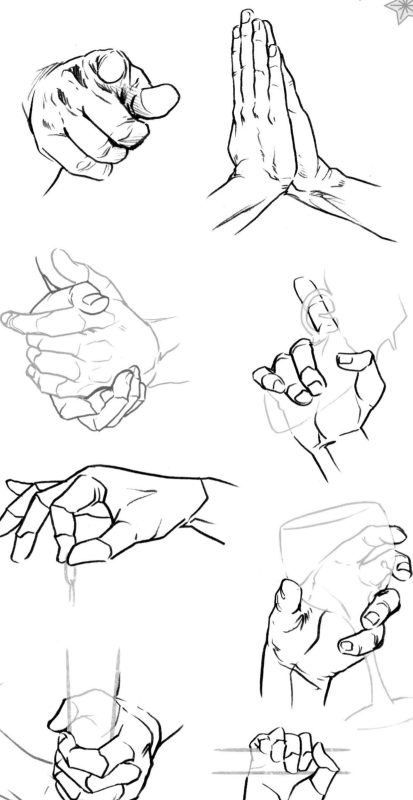
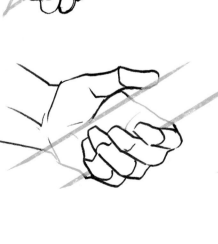
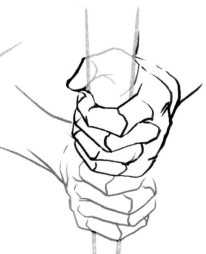

Legs

Like with arms, be aware of where the muscle groupings in the legs are. It's easy to give your character's legs some interesting definition.

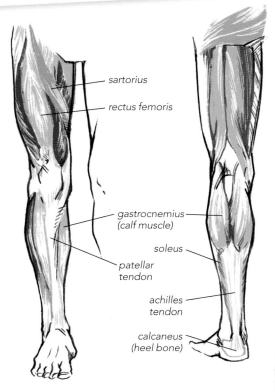

sartorius

rectus femoris

gastrocnemius
(calf muscle)

soleus

patellar
tendon

achilles
tendon

calcaneus
(heel bone)

LEG MUSCLES
Use this as a reference for where to add bulk when drawing muscular characters.

FORESHORTENING
The leg is segmented out here so that you can see where the knee is knee is placed on the first, and the calf is placed on the second, but you wouldn't normally have a line all the way around like that.

KNEES
In the first image, the left knee is more defined since it is supporting the character's weight. In the second image, the right leg appears shorter because it's bending forward at the knee.

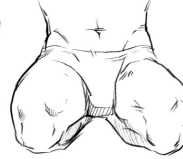

FORESHORTENED LEGS

Feet

Feet have a fairly limited range of movement, so they aren't quite as difficult as hands. However, it will still take a good deal of practice until you will be comfortable drawing them.

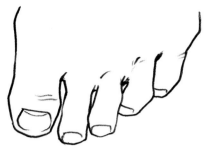

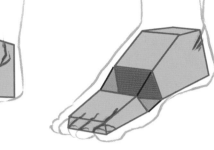

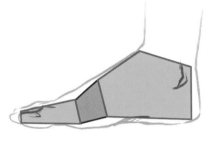

TOES

The big toe is fattest, but the second one tends to be longer. The last two toes curl inward. But if you look at people's feet, toes come in lots of sizes and shapes.

SHAPE AND MOVEMENT

Think of the foot as a series of connecting shapes and pieces. Make sure you always draw each piece instead of letting them meld together into a poorly defined shape.

The purple gap represents the part of the foot that can move. The heel and front pad are the immobile blocks connected by the stretchy center. Obviously toes can move too, but this is what you should keep in mind when drawing feet curling, arching, walking and running.

CONTRACTED MUSCLES

The muscles in the foot contract when a step is taken.

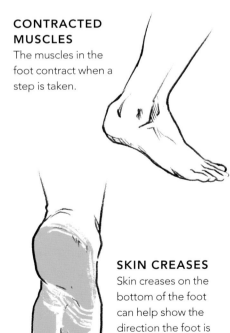

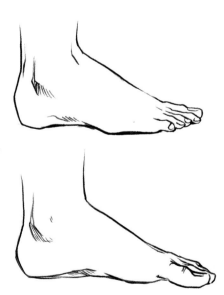

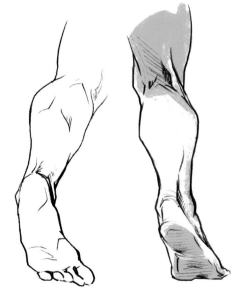

SKIN CREASES

Skin creases on the bottom of the foot can help show the direction the foot is twisting.

FEET IN PROFILE

When the foot is in profile with the pinkie toe facing you, the other toes are still mostly visible. When the big toe is facing you, the other toes are mostly hidden.

LOWER LEG MUSCLES DEFINED THROUGH MOVEMENT

The Achilles tendon in particular tends to be visible when walking or running.

Visit impact-books.com/shojofashionmangaboys to download bonus materials.

Body Types

Mixing up your body types will lead to a cast of characters that is relatable to a wider range of people. Now that you know how to draw each part of the body, you can work on changing up the final product!

DRAWING DIFFERENT BODY TYPES

You can alter the look of your character by changing the length and width of limbs, shoulders, hips and the torso—even the way characters stand.

A: Broad shoulders, narrow hips

B: Shoulders and hips same size

C: Narrow chest, wider hips, knees wider apart (bowlegged)

D: Sloping shoulders, wider hips and waist, closed legs with toes turned outward

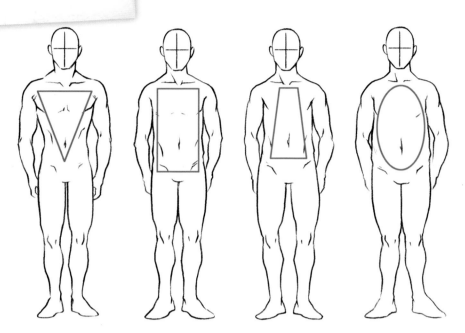

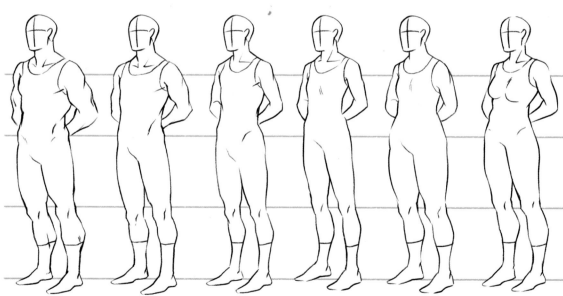

MASCULINE VS. FEMININE BODIES

Thicker chests, wider shoulders and obvious muscle definition all lead to a character looking more "manly," while larger breasts, wider hips and soft curves all lead to a more "womanly" look. However, not everyone exists on either end of this spectrum. Some characters will be more androgynous, like the third and fourth figure. Also, there's no rule that male characters can't take a few characteristics from the feminine side of the spectrum, or visa-versa.

Body Language

You shouldn't judge a book by its cover, but many people do anyway. What will your character's look and stance say about them?

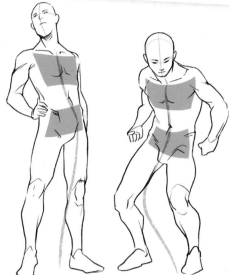

BODY LANGUAGE ADDS TO CHARACTER

The first figure is standing straight with shoulders and hips perpendicular to the spine. Create a new stance by changing the direction of the spine, hips and shoulders in different ways.

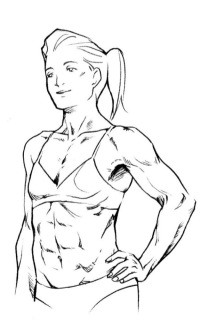

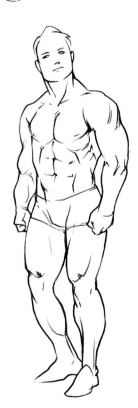

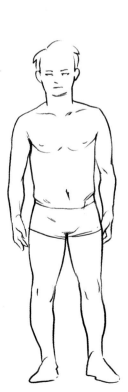

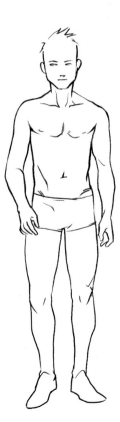

MUSCULAR WOMEN

We've been using male models for examples of musculature, but muscles work exactly the same way on female bodies. Even though it is rare to see, there is absolutely no reason female characters can't have bulky, extremely defined muscles like male characters often do.

MIX UP BODY TYPES!

The key to a diverse and interesting character lineup is realizing that people are not all the same size or shape (or color)!

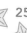

Bodies in Motion

Don't draw people just standing still, facing you, when you can draw them moving, or even just standing in more natural poses. Practice drawing natural looking poses like these.

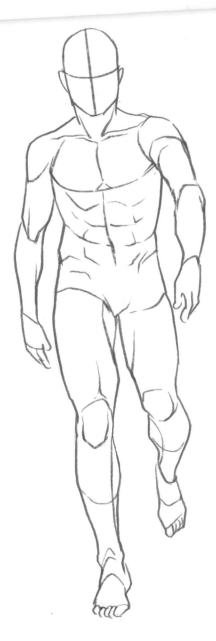

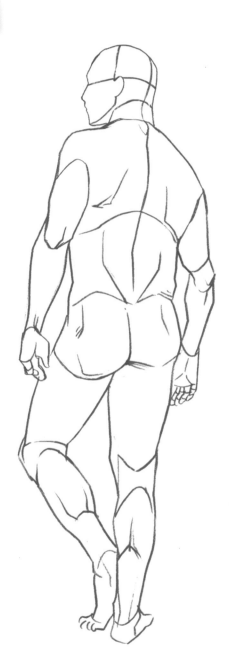

WALKING

Note the tilt of the shoulders and the way the hip of the body's right leg juts out to take the weight while the left arm swings forward to keep balance.

CONTRAPPOSTO

This is a pose where most of the weight is on one leg, which causes the shoulders to twist off axis a bit. Here you can see it in the way the shoulders slump off to the right to balance all of the weight on the right leg.

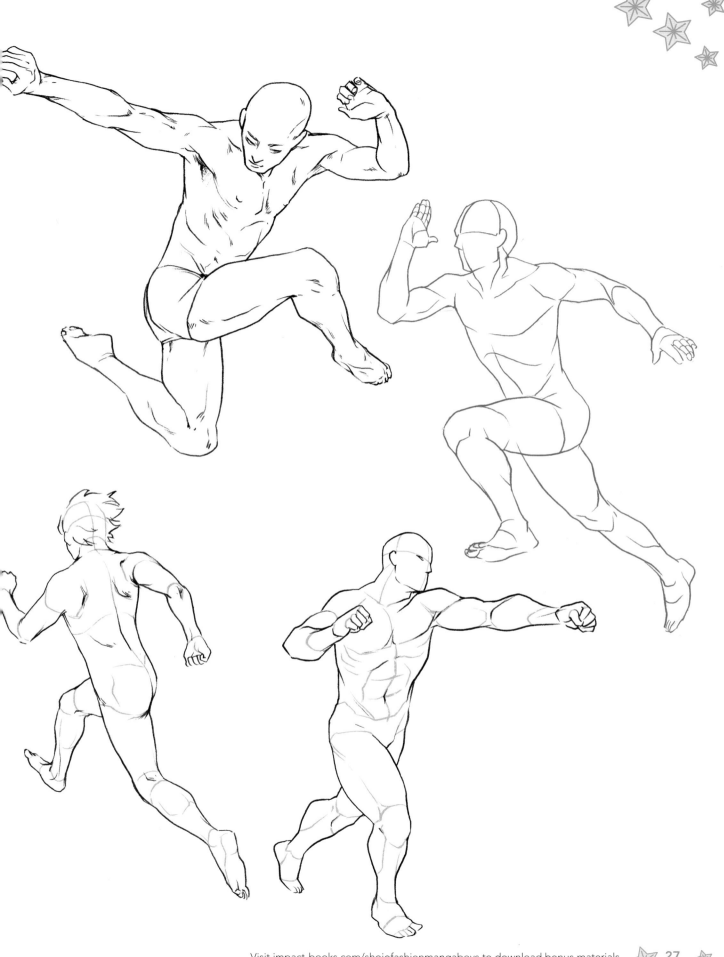

Relaxed Bodies

Relaxed poses can be just as interesting to look at and draw as moving body. Practice drawing relaxed poses like these.

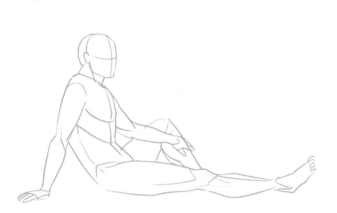

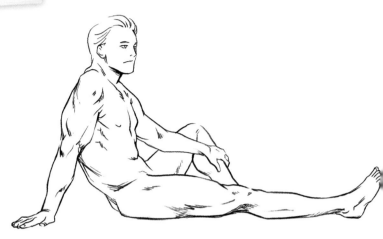

ROUGH SKETCH
Develop and then never lose the habit of drawing a rough sketch of your poses! A quick little featureless figure will make it easier for you determine if your proportions are right and all body parts accounted for before you start putting in lots of time to detail your lineart.

DRAMATIC MUSCLE DEFINITION
When the weight of the body is on one arm, the muscle definition in that arm is more dramatic. Also, consider the surface the body is on; here the floor he's sitting on causes a pretty straight line along the thigh, calf and bottom of the right leg.

If you aren't sure how to draw a pose like this one...

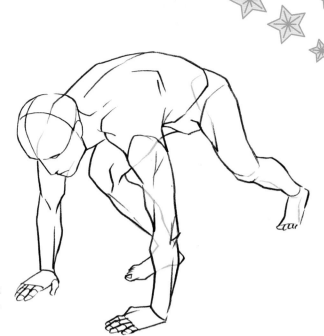

...try drawing it from a different angle. Than use that as a reference for how it would look twisted around. All the parts are in the same position, you just need to visualize them from different angles.

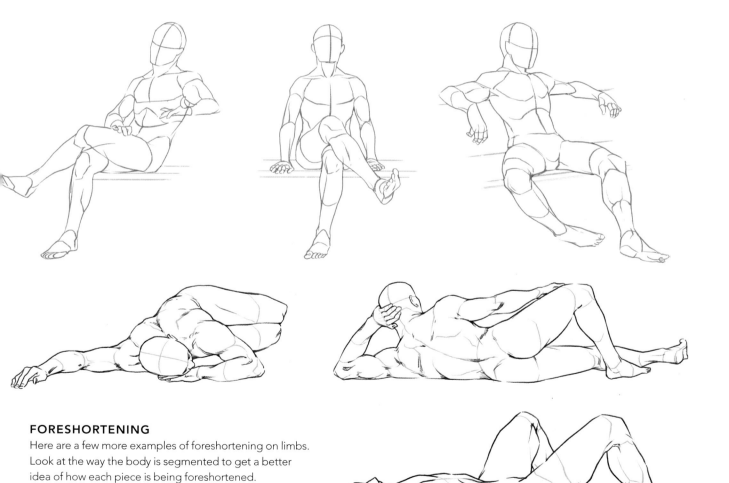

FORESHORTENING

Here are a few more examples of foreshortening on limbs. Look at the way the body is segmented to get a better idea of how each piece is being foreshortened.

3 | Drawing Faces

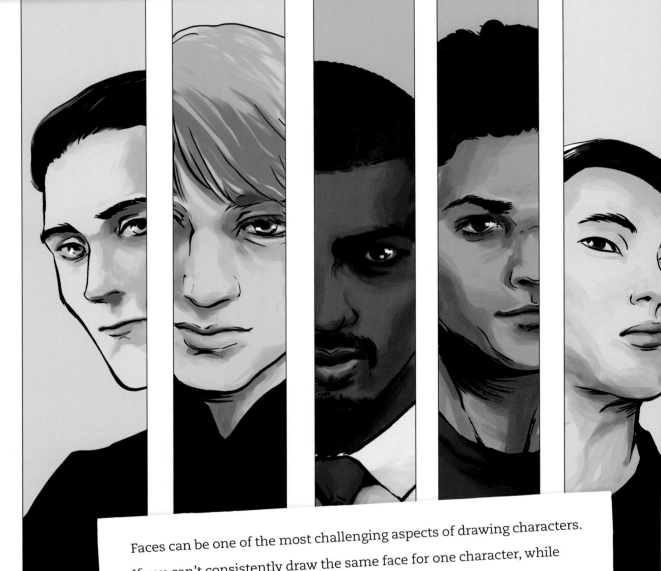

Faces can be one of the most challenging aspects of drawing characters. If you can't consistently draw the same face for one character, while making sure that each character has their own unique facial features, your readers are never going to be sure of who they are looking at.

In this chapter, we'll break down each facial feature and walk you through how to draw it. Then we'll put it all together at the end to talk about expressions.

Facial Structure

At their most basic, all faces have the same symmetrical features. Familiarize yourself with how to sketch them out so you keep everything in proportion and in place on a character's head.

 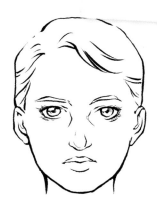

MALE VS. FEMALE FACES

Like the rest of the body, there are no hard and fast rules about what makes a face male or female. But generally men are drawn with sharper angles and bolder lines, while women have more pronounced lips, softer curves and longer lashes.

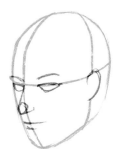 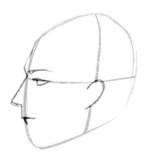

FACIAL STRUCTURE GUIDES

Use simple guides like this to make sure the face stays symmetrical. Remember that the eyes should almost always be in the middle of the head.

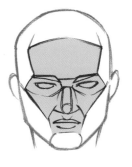 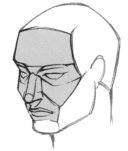 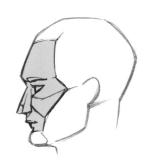

ANGULAR FACIAL STRUCTURE

Use this to make sure you represent the features accurately from different angles.

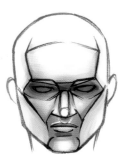 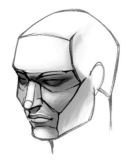 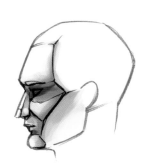

HIGHLIGHTS AND SHADOWS

Keep the terrain of the face in mind when coloring. Areas that contour outward like the forehead and cheekbones will catch the light, and inward contours like the brow and eye sockets will be more shadowed.

Eyes

Most people start by drawing the eyes first, since they are located in the center of the head, and they need to be placed perfectly across from each other.

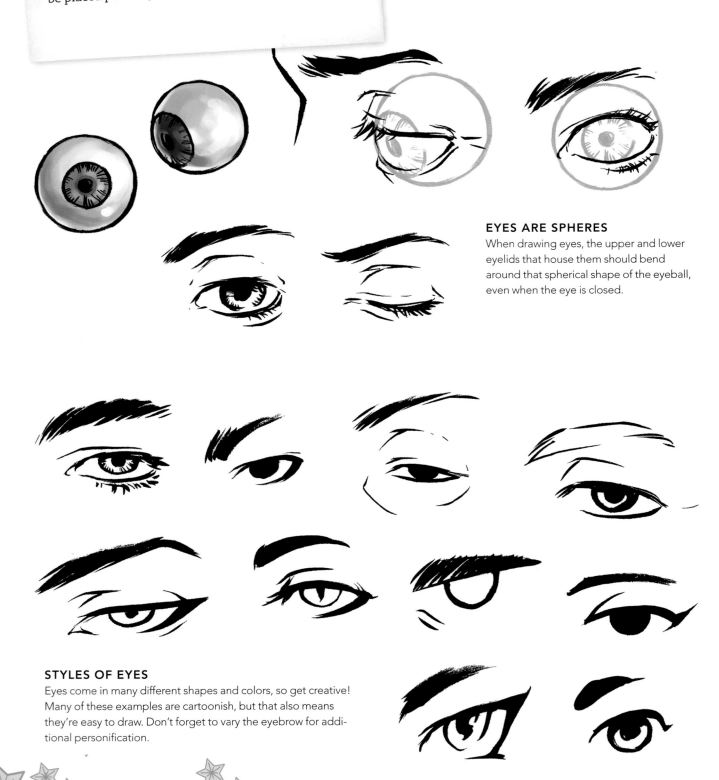

EYES ARE SPHERES

When drawing eyes, the upper and lower eyelids that house them should bend around that spherical shape of the eyeball, even when the eye is closed.

STYLES OF EYES

Eyes come in many different shapes and colors, so get creative! Many of these examples are cartoonish, but that also means they're easy to draw. Don't forget to vary the eyebrow for additional personification.

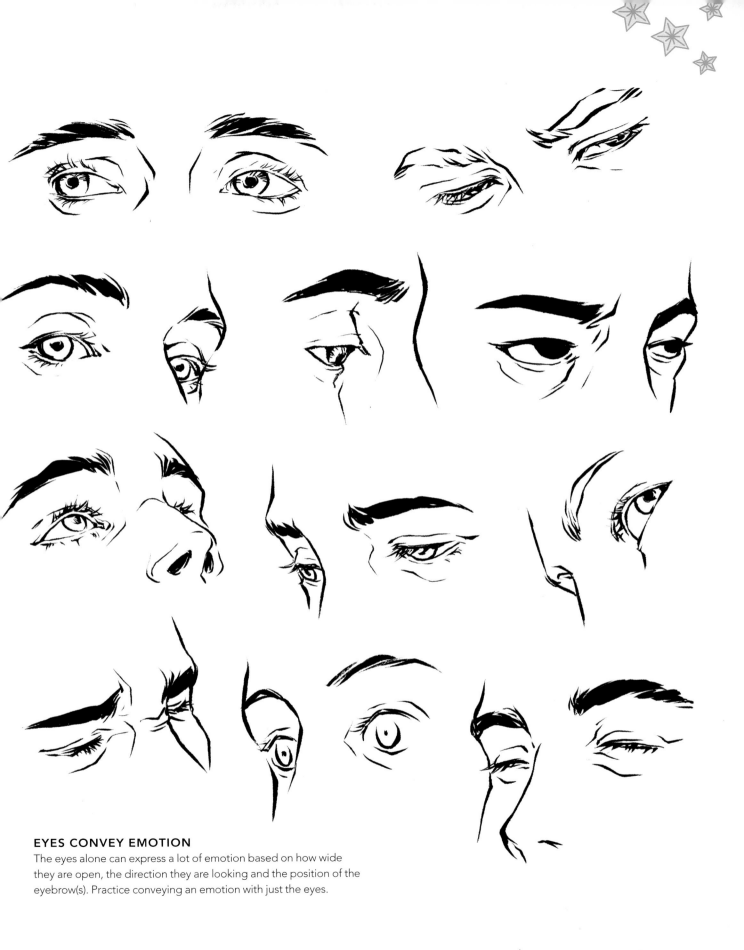

EYES CONVEY EMOTION

The eyes alone can express a lot of emotion based on how wide they are open, the direction they are looking and the position of the eyebrow(s). Practice conveying an emotion with just the eyes.

Noses & Mouths

Time to learn about the nose and the mouth! We're covering them together because when viewing the mouth from different angles, the nose serves as a clear indicator of the perspective.

BASIC SHAPE OF THE NOSE
Obviously noses can vary in width, length, bridge height, shape and so on. Practice drawing different shapes and styles.

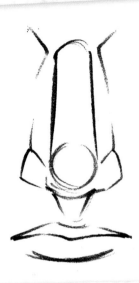
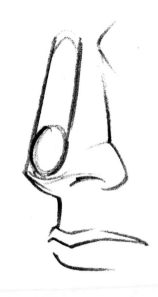
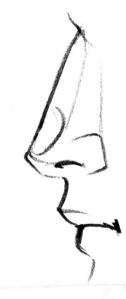

DRAW LIPS

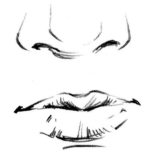
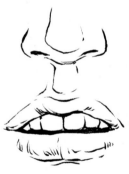

1 OUTLINE
Outline the height and width of the lips. Make the top lip is roughly half the height of the bottom lip.

2 BUILD UP SHAPES
Add a dimple to the upper lip to give it its shape. Outline with shallow Vs above on the top and bottom of the upper lip.

3 CONNECT LINES, ADD DIMENSION
Connect the lines of the top lip to the corner of the mouth. Then the lower lip is just a large curve on the bottom. Add the lines of the skin in the shadowed (lower) area of each lip to give dimension and realism.

4 INK IT!
Carefully choose where to put your lines; if you draw the lips all in the same heavy complete lines, it will look very flat. Use light lines on the lips themselves, and leave it white where you want them to look glossy and supple. Use darker lines where the lips press together and at the corners of the mouth.

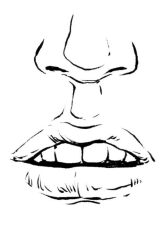

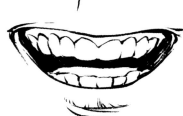
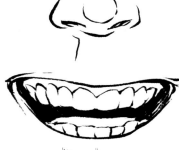

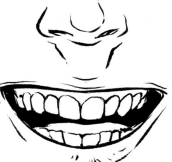

TEETH

There are a few different ways to handle drawing teeth: draw each individual tooth; draw all the teeth with just a gesture and a line between them; or just leave the teeth as an indistinct white band. They are all valid, though drawing each individual tooth is probably the hardest to pull off. Getting the additional detail right is important since mistakes will become more obvious.

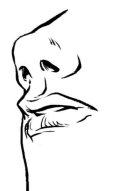
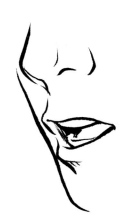

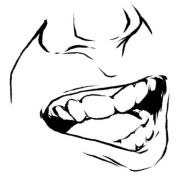

TYPES OF LIPS

Play around with different types of lips: thin, thick, short and long. These little details make a person's face distinctive.

Ears

Like fingerprints, every ear is different. So you don't have to worry about trying to draw them the exact same way every time. Just get the structure down.

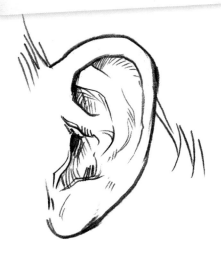
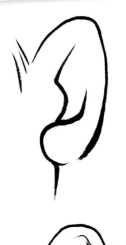
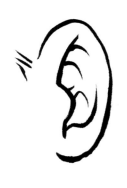
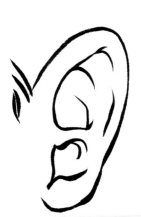
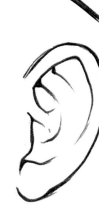

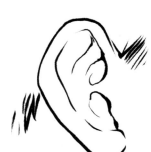

THE HUMAN EAR
The ear shown in full realistic detail so you know what you'll be simplifying for a manga style.

DRAW EARS

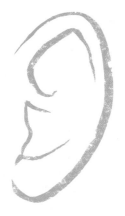
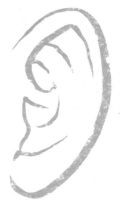

1 OUTLINE
Draw the overall outline of the shape of the ear.

2 ADD LINES
Fill in the prominent lines.

3 CREATE THE OUTER SHELL
Continue building up lines to create the outer shell of the ear.

4 ADD DETAIL
Add final details such as inner ridges and contours.

Face Shapes

Now let's look at how to create variety in appearance using different shapes and sizes of facial features. Don't be afraid to give someone a large forehead, widely spaced eyes, gaunt cheeks or a bold nose. That's what people really look like! Vary the size, shape and spacing of features to create distinctive and unique face shapes.

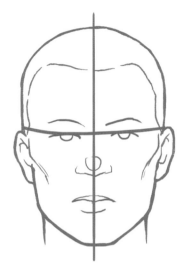

BASIC FACE STRUCTURE
All of the features are evenly spaced. The eyes directly in the middle of the head, with nothing too big or too small.

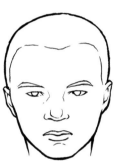
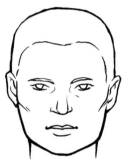
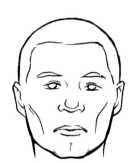
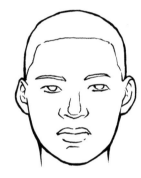
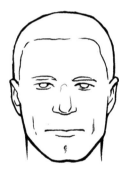

FACIAL COMPOSITION
Think of faces as compositions of varying shapes. Here are some breakdowns of different faces and how the shape composition changes with each one.

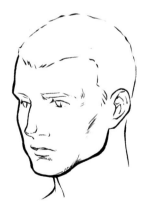
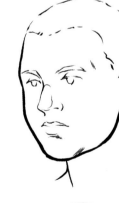
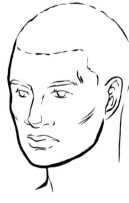

Face Styles

Once you've learned how to make faces look different, you can start exaggerating and simplifying those features into a stylized look that suits you.

BASIC PROFILE STRUCTURE

The basic structure of the profile is very simple. This time the ear is in the center instead of the eyes. Think about where the neck connects to the head.

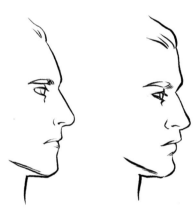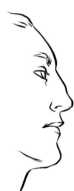

STYLE OPTIONS ARE ENDLESS

Some people have longer or flatter noses, jutting or shallower chins, straight or receding foreheads, and so on.

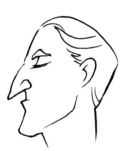

WALK BEFORE YOU RUN

There are really no limits or rules on how to stylize the human face, but you should practice mastering the features before you start simplifying them!

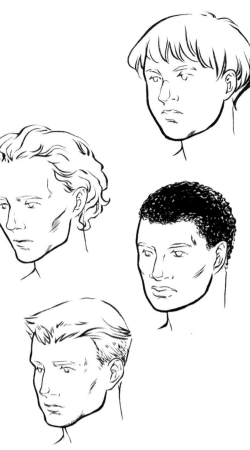

Hair

When drawing hair, think of the whole effect instead of where each individual strand goes. You don't want to draw every strand; just enough so people know what you're aiming for. There could really be an entire book dedicated just to hair styles, but let's talk about a few tips for making sure your hair looks like it fits the head it's on.

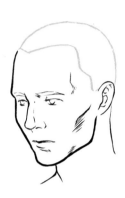 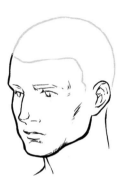 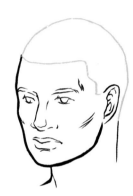

HAIRLINES
Before you start drawing hair, think about where the hairline is. Is it low or high? Curved or a widow's peak? Keep this in mind for whatever hairstyle you're drawing.

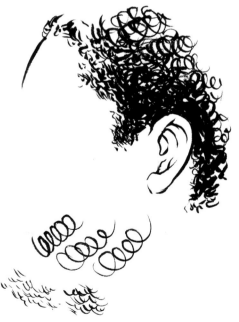

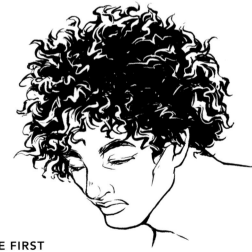

SMALL TIGHT CURLS
Draw many narrow curly Qs over the same area. The white space looks like highlights or skin peeking through. For the hairline, tiny non-uniform strokes give the effect of short hairs leading up to the longer ones.

ALWAYS DRAW THE HEAD SHAPE FIRST
Even if your character has voluminous hair, draw the whole head, establish the hairline, rough out the shape of the hair, and then actually draw it in.

DRAW A FADE HAIRSTYLE

For many men's hairstyles, the hair tapers as it goes down the neck.

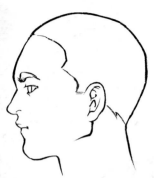 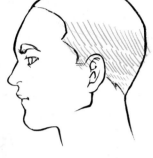 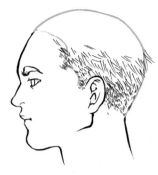 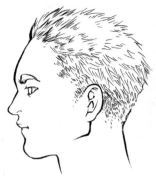

1 ESTABLISH THE HAIRLINE
Start by establishing your hairline.

2 ESTIMATE LENGTH
Estimate what strand length you want to have at each level.

3 ADD STRANDS OF HAIR
Use tiny strokes for the tiny strands of hair, and longer strokes for the longer strands. Draw them in little clumps instead of uniformly.

4 ADD DETAIL
Add final details. Stagger the lengths a bit. You don't want a clear line between short, shorter and shortest strands of hair. When adding the stubble at the very base of the taper, try tiny lines instead of dots.

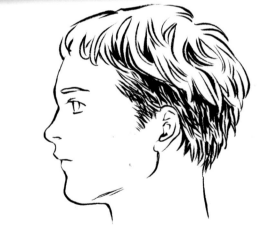 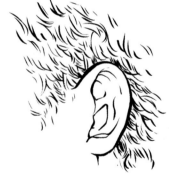

WAVY HAIR
For naturally wavy hair, give the lines a bit of a curve—even on the tiny hairs.

LIGHT VS, DARK HAIR
Light-colored hair gets a lot of negative space. Don't fill it up drawing every strand. Just draw the lines around the edges of a clump or in shadowed areas. Dark hair is mostly ink, so it gets more lines. Leave white space in strands and narrow clumps for highlights.

Facial Hair

The techniques for drawing facial hair aren't really any different than techniques for drawing hair on the head. Use the same tiny lines, clumps and careful use of white space.

FACIAL HAIR PLACEMENT
The blue marks indicate where facial hair generally will grow.

EMOTIONAL EFFECTS
Remember that facial hair will be affected by your character's expression.

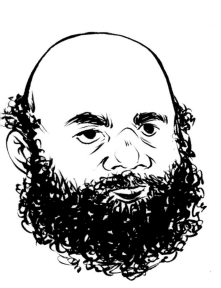

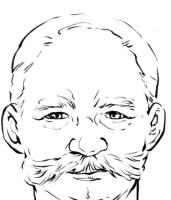

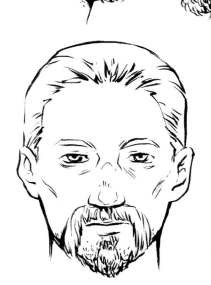

Age Progression

Being able to draw the same character at different ages can be one of the most difficult skills to master. You have to think a lot about the subtle ways bodies change as they age, and how to represent in ink the little tells we see on other people's faces to figure out their age.

PROPORTION IN ADULTS VS. CHILDREN

Adults have very different proportions from children. They aren't exactly the same from person to person, but remember that children are going to have narrower shoulders and shorter necks that make their heads look really large. The head is also rounder and smaller. The eyes are the same size for life, so on a child's small skull they look particularly huge.

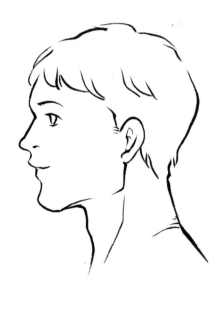

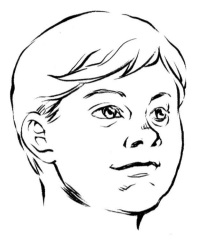

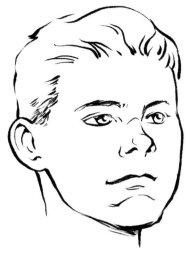

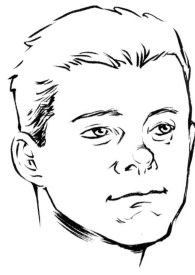

AGE 12

The cheeks are full of baby fat. The features are squished close together. The nose is shorter, without much definition. Overall the features are softer and rounder.

AGE 19

The jaw has started to square out. The face is longer, so the features are less squished, and cheeks are less round.

AGE 27

No more youthful roundness, and there's a few more lines pronouncing the puffy lower lid of the eye.

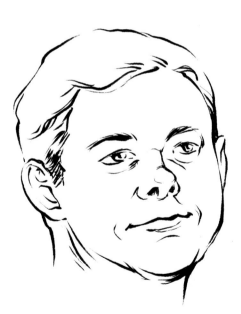

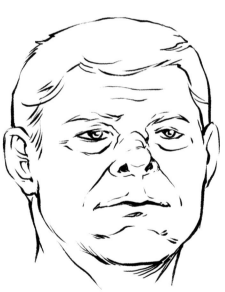

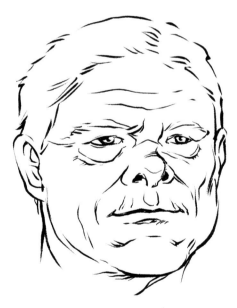

AGE 34

Now more lines are appearing under the eyes and around the mouth. He's putting on some weight so you can see a hint of a second chin and his cheeks are getting round again. Nostrils are a bit larger as everything on the nose starts to sink downward.

AGE 52

Now the wrinkles are really settling in on the forehead and around the eyes. The top eyelids are starting to droop and make the eyes look smaller. The jowl lines are also firmly established.

AGE 68

More wrinkles, and his hair has thinned out a lot. Now you can see lines around his lips and cheekbones. Everything is sagging now. The base of the nose seems much larger thanks to the cartilage growing and sliding down over a lifetime. Gravity!

 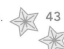

Facial Expressions

People don't always feel just one emotion at a time. Learning to represent the complexity of human emotions through facial expression is important. Here are some examples of how it might look when surprise gets mixed with sadness, or fear is mixed with anger. Pay attention to things like eyebrow placement and angle, shape of the mouth and openness of the eyes.

	SAD	*FEARFUL*	*DISGUSTED*
This graph is necessary for my point to come across. The different base expressions interact along the X and Y axis and combine for a new expression.			
HAPPY			
ANGRY			
SURPRISED			

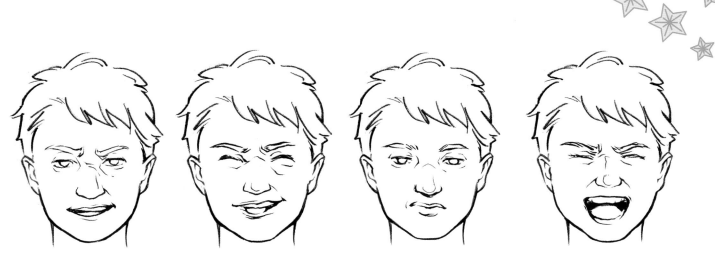

WATCH FACIAL EXPRESSIONS FOR CLUES

Watch people's faces to get an idea of what minute movements are informing you if someone is mocking, teasing, excited or unimpressed.

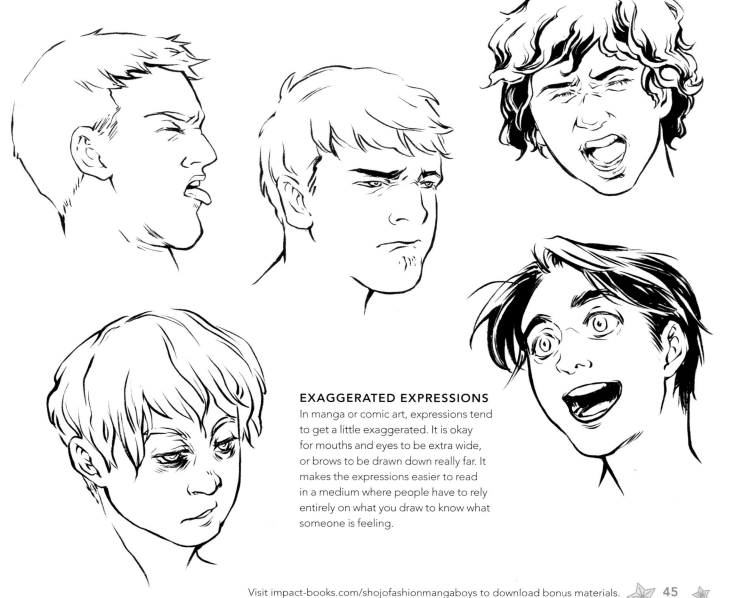

EXAGGERATED EXPRESSIONS

In manga or comic art, expressions tend to get a little exaggerated. It is okay for mouths and eyes to be extra wide, or brows to be drawn down really far. It makes the expressions easier to read in a medium where people have to rely entirely on what you draw to know what someone is feeling.

Angles

Now that we've talked about all of the components of the human face, put it all together! Practice drawing faces from different angles and with different expressions. Don't forget to rough out the structure of the head first so that you know where everything goes and what the correct proportions are before you do the details.

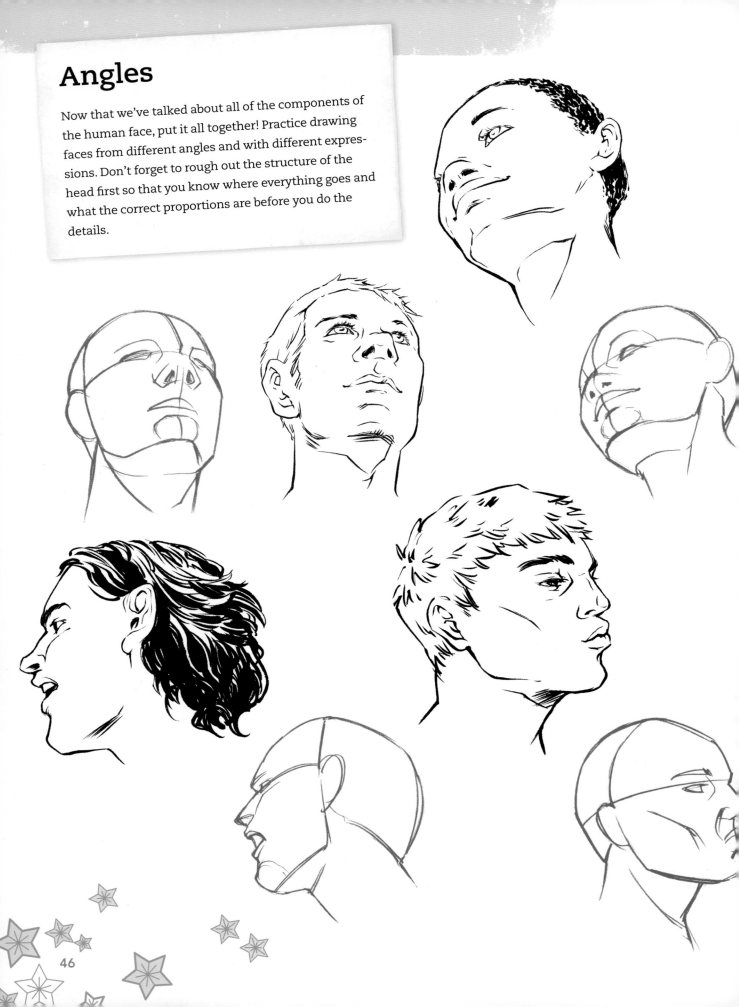

Accessories

The possibilities of creating distinct characters are endless! Once you've gotten the hang of making characters look unique with the size and shape of their features, don't forget to spruce them up a bit with other details. Freckles, scars, piercings, tattoos, eyewear, hats and makeup are all great ways to add personality and interest to your character.

4 | Drawing Clothes

Whether you love spending hours thinking about how your characters dress, or have never given it a thought and have no idea where to start, this chapter is for you. While there is clearly no possible way to cover every type of clothing, we will cover a lot of the staples of men's fashion, plus a few that aren't so common. This chapter is geared to help you get ideas on what your characters might be caught wearing—whether it's a casual summer day or winter at a business formal—and help you figure out how to draw it.

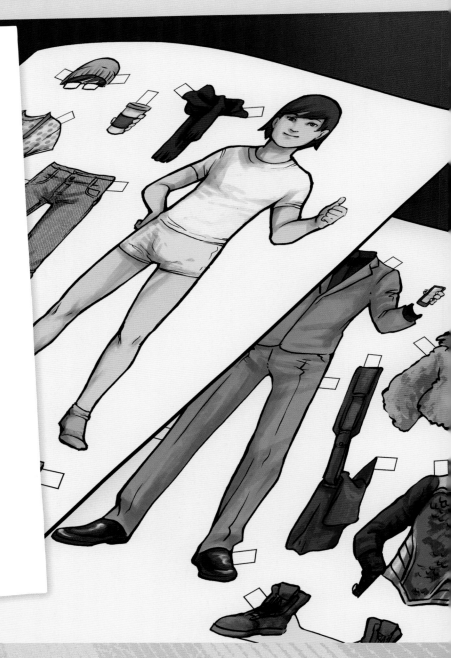

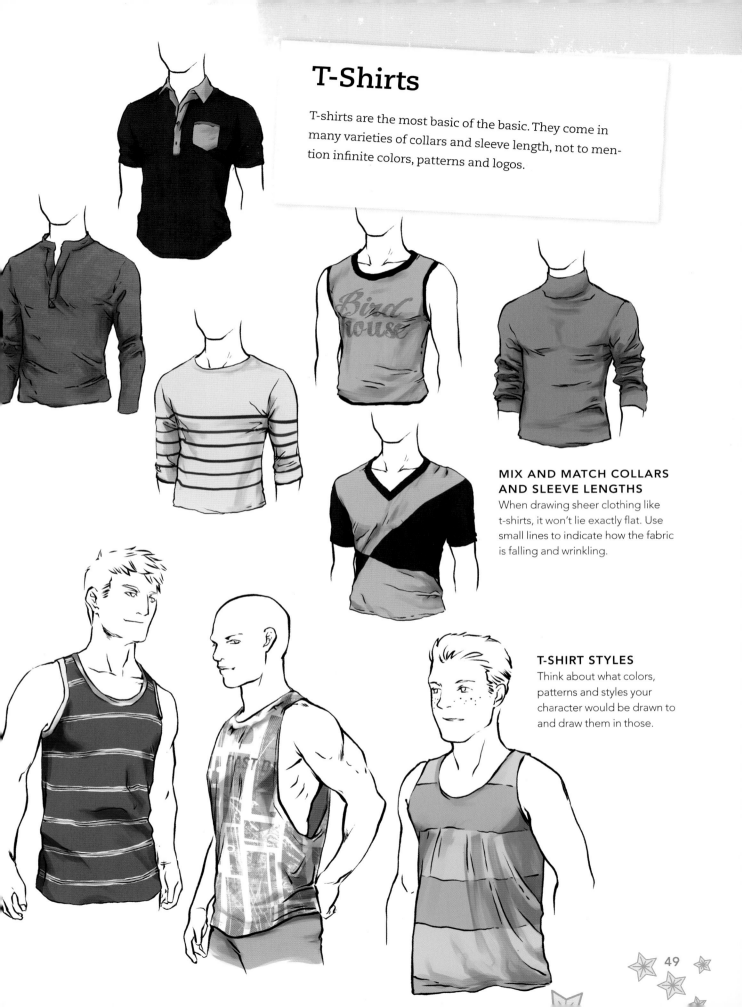

T-Shirts

T-shirts are the most basic of the basic. They come in many varieties of collars and sleeve length, not to mention infinite colors, patterns and logos.

MIX AND MATCH COLLARS AND SLEEVE LENGTHS

When drawing sheer clothing like t-shirts, it won't lie exactly flat. Use small lines to indicate how the fabric is falling and wrinkling.

T-SHIRT STYLES

Think about what colors, patterns and styles your character would be drawn to and draw them in those.

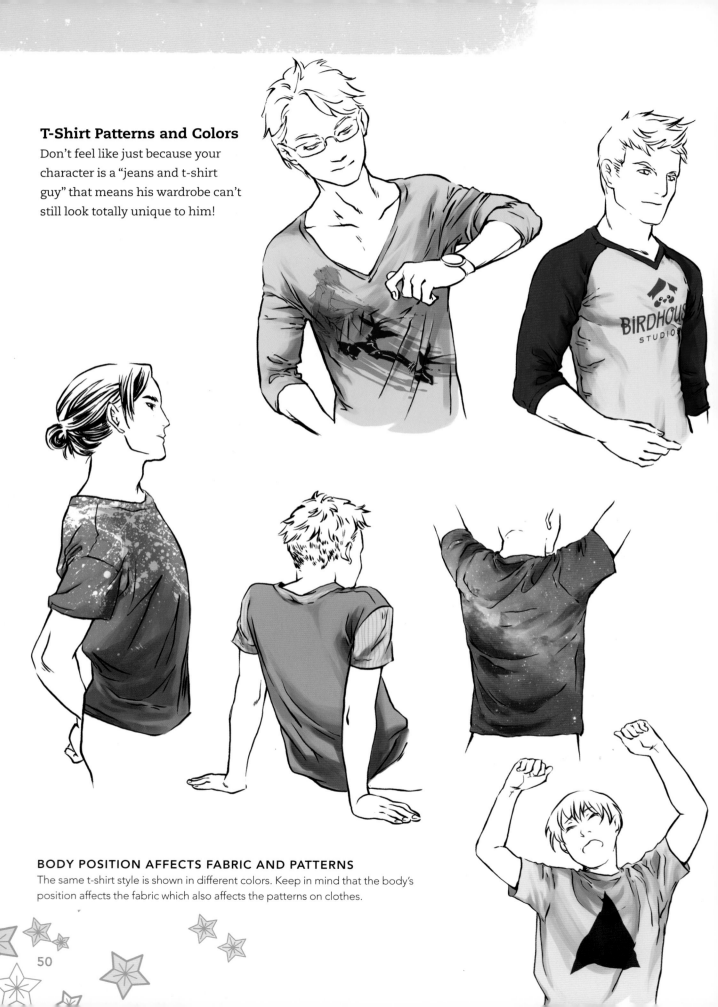

T-Shirt Patterns and Colors

Don't feel like just because your character is a "jeans and t-shirt guy" that means his wardrobe can't still look totally unique to him!

BODY POSITION AFFECTS FABRIC AND PATTERNS

The same t-shirt style is shown in different colors. Keep in mind that the body's position affects the fabric which also affects the patterns on clothes.

DRAW A GRAPHIC T-SHIRT

Want your character to be able to show off his appreciation for his favorite band, movie or comic? Follow the steps to draw a graphic t-shirt .

1 ESTABLISH THE POSE
Pick a pose and make sure the clothing responds to the body. Here the jumper is loose on the body so it bunches up around the stomach as the torso bends forward.

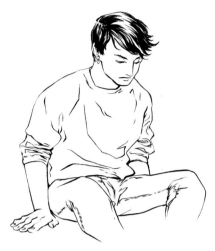

2 CLEAN UP
Clean up the line art. Most of the creases are on the elbow where the sleeves are pushed up. The stomach just has a few large folds so the lines are longer and further apart.

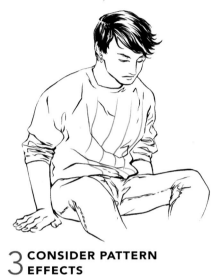

3 CONSIDER PATTERN EFFECTS
The red vertical lines show how the shirt pattern will be affected by the ripples in fabric.

Anything would be better than this.
• Serrure •

4 CONSIDER IMAGE PLACEMENT
If the character was standing straight and tall facing you, the image would appear like this.

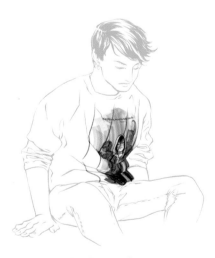

5 DRAW THE IMAGE
When drawing the image onto the shirt, think of it as being in sections. The section gets cut off horizontally where there is a big fold. Then draw a piece a little further down on the image on the next fold.

6 ADJUST FABRIC DETAILS
In this case, the fabric is also distorted vertically because he's sitting at an angle and his thick jumper is pulling a lot toward the front.

Dress Shirts

Button-ups or dress shirts are shirts that open and button up in the front, usually also with collars and cuffs. They are very typical dress wear for men, particularly in any white-collar field. The more expensive ones will come in a variety of richer colors and decadent cloths.

Remember to keep buttons evenly spaced. Also keep in mind that sometimes dress shirts have an extra flap of fabric that hides the buttons, or they can be hidden under ties.

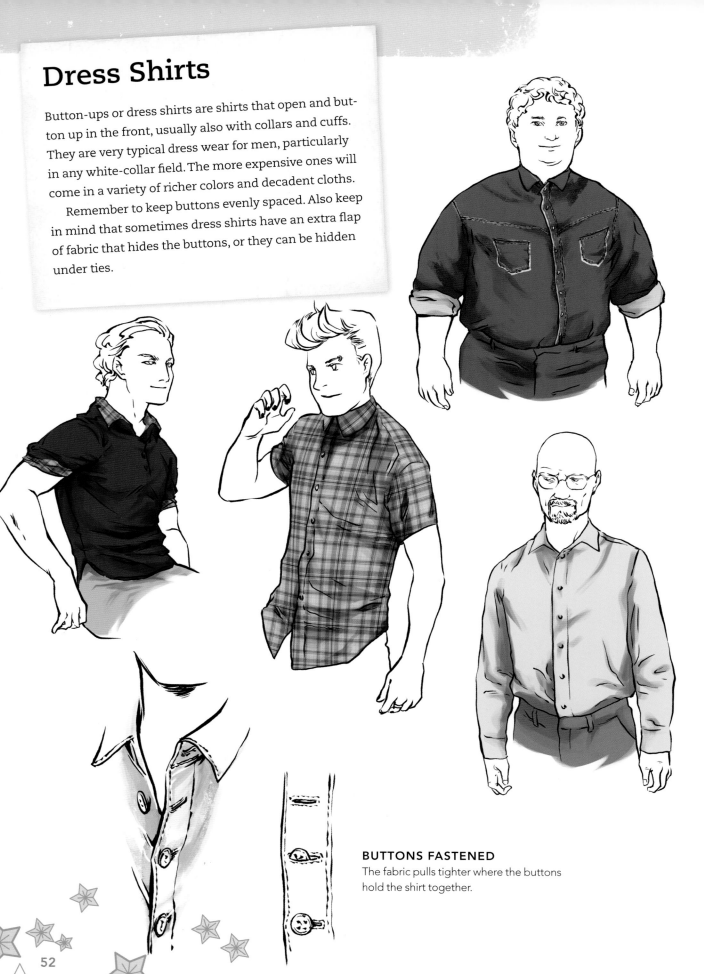

BUTTONS FASTENED
The fabric pulls tighter where the buttons hold the shirt together.

DRAW MOVEMENT IN A TUCKED SHIRT

Follow the steps to draw movement in a tucked shirt.

When standing straight and facing forward, the buttons go down the front-center of the body. If the shirt is tucked in, there will be some creasing and fabric bunching at the waistband.

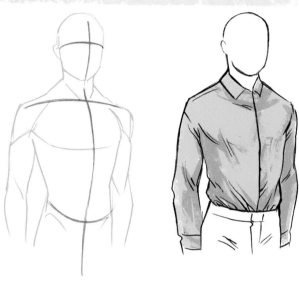

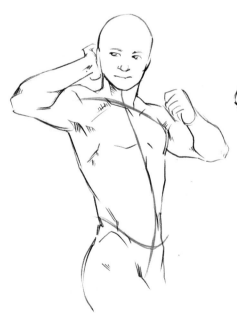

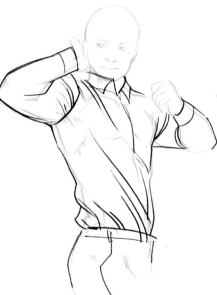

1 ESTABLISH THE POSE
When the body twists, the central line of the body moves.

2 DRAW THE SHIRT AND CREASES
That center line is represented by the line of buttons on the shirt. Since the shirt was tucked in when facing straight ahead, the twisting motion will pull that fabric toward the right, where the torso is turning. The right arm is raised up as well, which creates more upward-pulling creases.

3 MAKE FINAL ADJUSTMENTS
Raising the right arm and shoulder pushes up the shirt collar (which holds its own shape), crumpling it against the shoulder, and partially obscuring the chin. The movement stretches the fabric by the buttons. Add shadowed gaps in between buttons, where the fabric is being pulled apart.

Hoodies

Hoodies are one of the most popular forms of outer-wear. Because they can be worn open, partially open, fully zipped, with hoods up or down, and come in many styles, they have a lot of potential character.

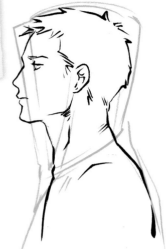

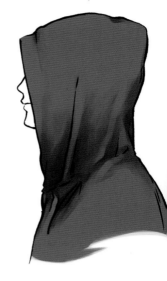

Hoodies are usually made of thick fabric, so the seam makes the back of the hood stick out. If someone pulls the hood forward far enough, it will obscure most of the head and face.

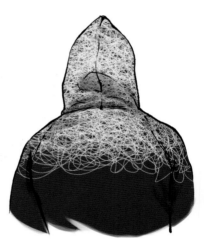

HOOD UP
When pulled up, the back of the hood can appear a bit shapeless, so add a bit of detail by hinting at the seam and the fabric creasing around the neck.

HOOD DOWN
When pulled down, the hood bunches up against the nape.

CHILD'S HOODIE
Children's hoodies have less fabric so they retain more of their shape when the hood is down.

STRIPES
When you're doing any striped tops, think of how the stripes carry on to the sleeves. In this case, they are evenly spaced so if his arms were hanging down the pattern would appear unbroken.

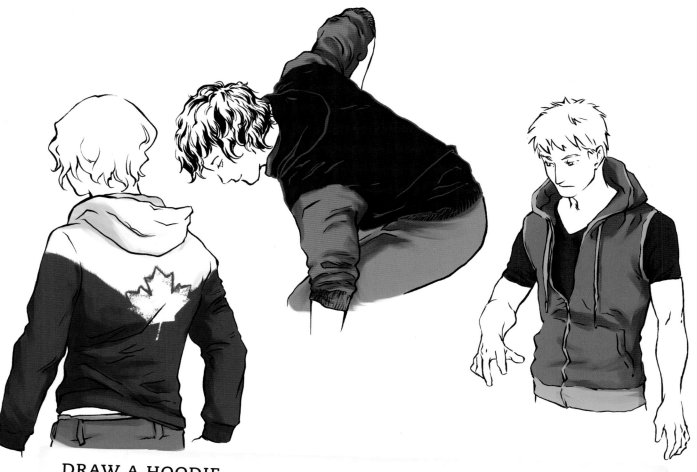

DRAW A HOODIE

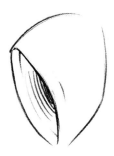

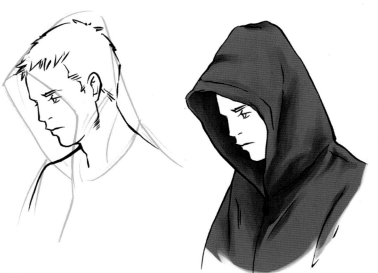

1 START WITH THE BASIC SHAPE

Start with a conical shape to go over the head, but with an opening that is more of an oval.

2 DRAW THE HEAD AND HOOD

Draw the head and mold the hood around it. The bottom part of the hood tapers around the face and connects back to the front of the hoodie at about the level of the collar bones.

Patterns & Textures

Drawing patterns and textures takes an eye for detail and some patience, but it doesn't have to be difficult. Here are some tips on how to draw some common ones found in men's clothing.

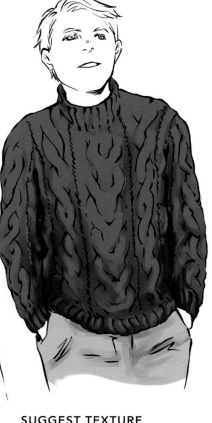

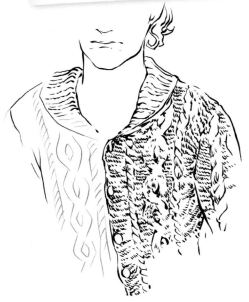

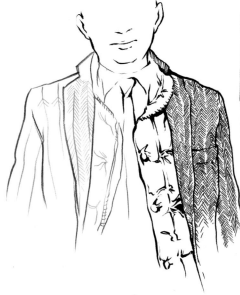

CABLE-KNIT PATTERN
First, the pattern was sketched out in red. When you want to draw a particularly noticeable detail, like the cable pattern here, use longer lines with fewer small lines. This helps them stand out.

HERRINGBONE PATTERN
The vertical guidelines, which center the upside down V that makes a herringbone pattern are shown in red.

SUGGEST TEXTURE
You don't necessarily have to draw in the texture, but simply suggest it. Here, a brush pen was used to express texture with varying line-weight and unbroken wobbly lines that follow the cable-knit pattern.

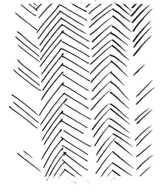

DRAWING HERRING-BONE TEXTURE
This pattern also doesn't have to be perfectly aligned. It is tight enough that it still comes across as a very symmetrical pattern.

DRAWING KNITTED TEXTURE
Use short curved lines in rows to represent knitted texture. The lines don't have to be perfect; they even look more organic when they aren't. In shadowed areas of the garment, use bolder lines. In lighter areas, use thinner lines or leave gaps in the texture.

CROSSHATCHING

To cross-hatch, use a series of light and/or thin lines going one direction. Then add shadows with more sets of lines going another direction.

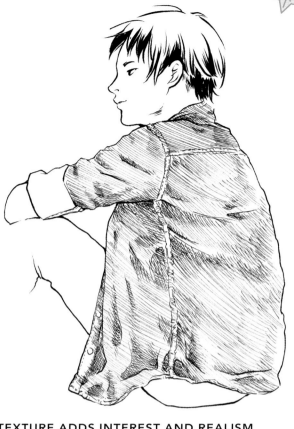

STITCHING

In many garments, but most notably in denim and leather, the stitching is as much a part of the design as the style of the clothing, so get creative! You can use tight, broken lines to represent the stitches. It doesn't have to be perfect.

TEXTURE ADDS INTEREST AND REALISM

Here's an example of what a difference drawing in the texture makes. Cross-hatching was used to texture this denim jacket. Leaving the cuff untextured makes it obvious it's the reverse side of the fabric, and the whole jacket feels more real than what just the lineart can provide.

STITCHING FROM A DISTANCE

The faraway stitching still has two lines, but drawing the lines on top of each other conveys that it is more distant.

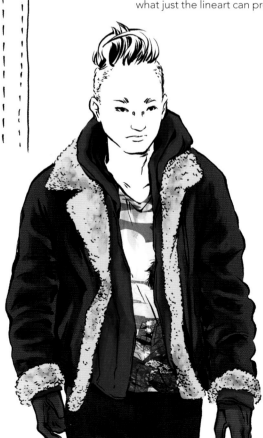

WOOL TEXTURE

Drawing tightly coiled wool is as easy as creating dots. You don't have to draw every individual curl. Wool or fur will have a soft outline, so just draw tiny bumpy or curved lines with lots of gaps.

DRAW A CABLE-KNIT PATTERN

Knit patterns have to convey texture as well as patterns shifting across cloth, so they can be tricky. Follow the steps to draw a cable-knit pattern.

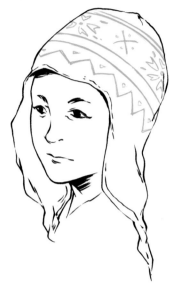
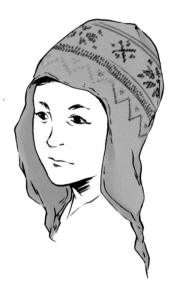
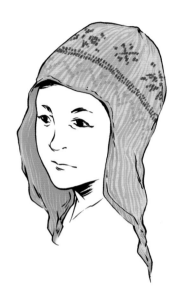

1 OUTLINE
Start with your outlines, and then you can sketch in the pattern with blue pencil.

2 DRAW THE PATTERN
With knit garments, the color differences are separate yarns. They are actually part of the structure of the garment, and the weave is basically several tiny blocks of color. So the patterns should look like little pixels, instead of a smooth line like a printed design.

3 HIGHLIGHT
Add more texture by highlighting the ribbing on the hat.

4 FINISH WITH SHADOW DETAIL
Finish by shadowing the entire garment. This adds dimension. Without the connecting shadows, the colors look disparate and flat.

BLACK-AND-WHITE PATTERN
You can also do cable-knit patterns in black and white; just use the pixel/block method.

Outerwear

There are various types of outerwear to put male characters in; it doesn't always have to default to hoodies. Jackets and coats can vary in length, fit, material, as well as the use of zippers and/or buttons. There are different collars, lapels, pockets and fabric textures to consider. Go nuts!

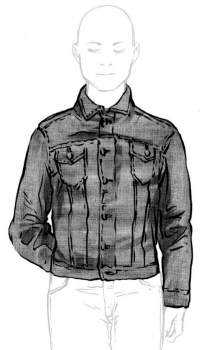

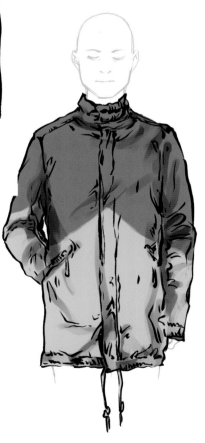

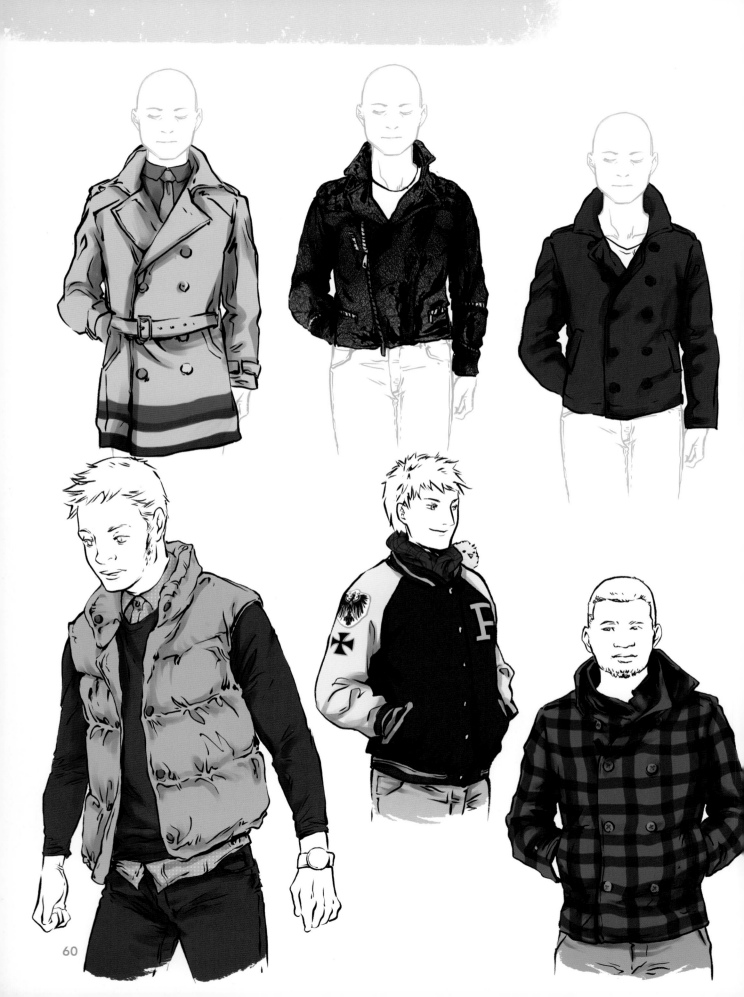

DRAW A LONG COAT FROM BEHIND

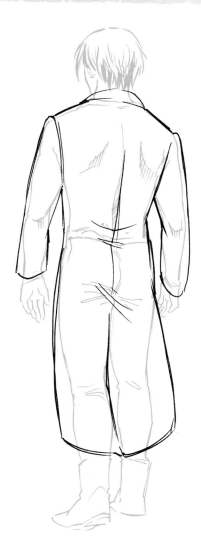

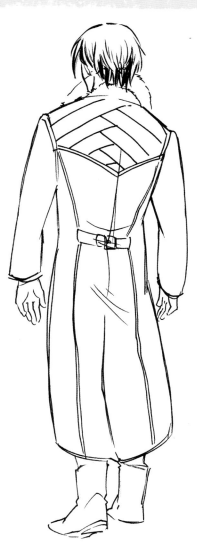

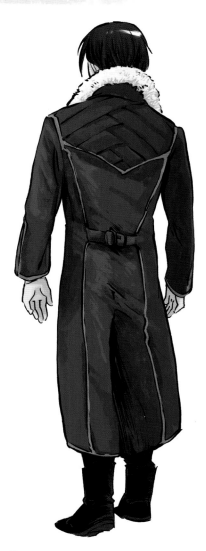

1 DRAW THE SKETCH

Even when drawing someone in a long coat, first sketch out the body underneath. A long coat has big swaths of fabric, and if you just draw the coat then add the limbs afterward your anatomy will probably get weird.

2 CONTOUR THE COAT TO THE BODY

A coat can still be tailored and follow lines of the body. Here the coat tapers at the waist. The fabric is draped against the movement of the back leg.

3 ADD PULL LINES

The left side of the coat is resting against the back leg, so there are pull lines where it is tugging the fabric of the right side of the back of the coat.

Formal Coats

Formal coats are generally worn over suits, have long labels, go down past the hips and are usually double-breasted (that means the fabric at the front crosses over the chest twice, and is held in place with two sets of buttons).

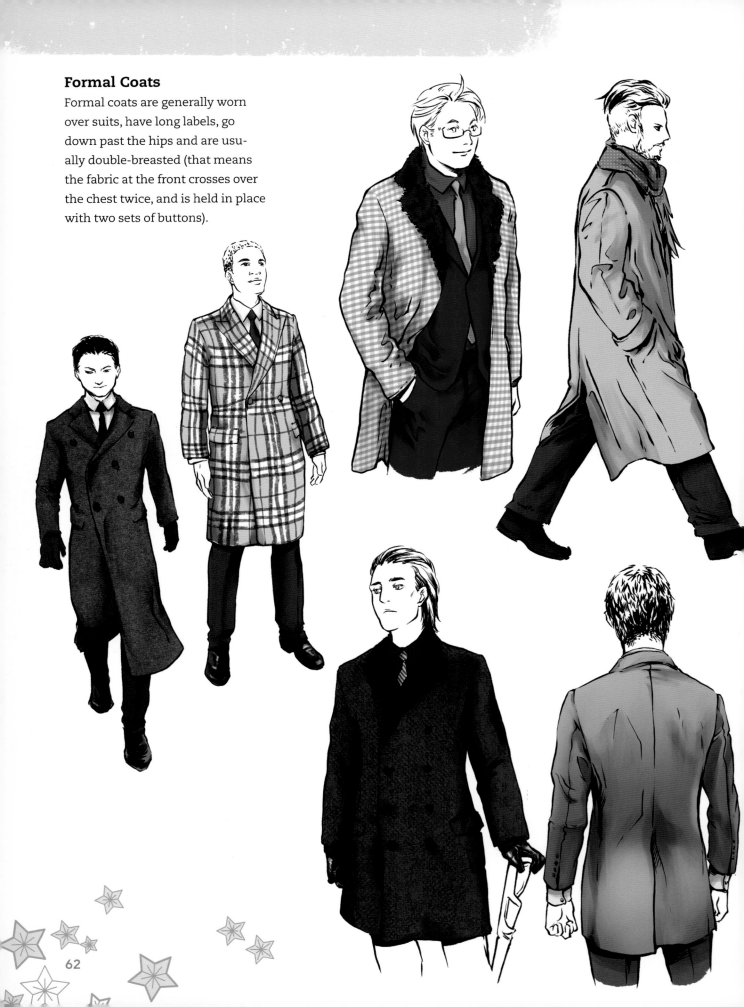

DRAW EXTREME COAT MOVEMENT

Follow the steps to capture that classic moment where your character is hit by a gust of wind so strong that his coat flaps wildly behind him.

1 SKETCH THE POSE

Sketch out the pose. Remember it's almost impossible to look into a strong wind, so your character should be really feeling it.

2 ADD FABRIC CREASES

He's holding the lapels of the coat in hand and pulling it forward, which makes the fabric tight against his back. The fabric creases up toward his fist, where it is bunched up.

3 STRETCH FABRIC AROUND THE BUTTONS

The buttons are keeping the coat closed, so the fabric flies out just under the final button, and the fabric strains against it.

4 ADD FINAL DETAILS

The fabric flying out behind him really gives an idea how strong the wind is, in addition to the initial pose. Where the right side of the coat was caught in front of his body, it's plastered to his right leg.

Winter Wear

Up until now, we've mostly been dealing with cool weather wear. Now we are talking winter. Heavy snow and sub-freezing temperatures means heavier coats, thick scarves, hats, gloves and lots of layers.

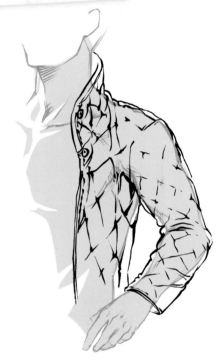

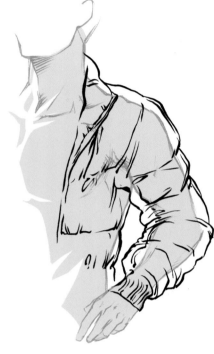

THIN FABRIC
With thin fabric, like this cardigan, the outlines don't get far away from the skin.

QUILTED FABRIC
This quilted jacket is a little thicker, so the lines extend further.

THICK FABRIC
Thick winter jackets have more insulation, and you can see that from the way the outlines rest far away from the body.

CHILD SIZE
Children's clothing has smaller proportions but the fabric has the same amount of padding as an adult's jacket. It makes kids look like little puffy smooshballs!

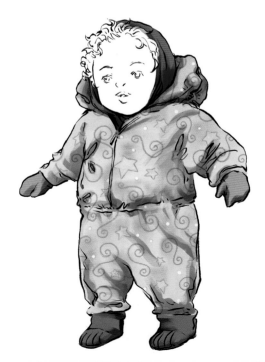

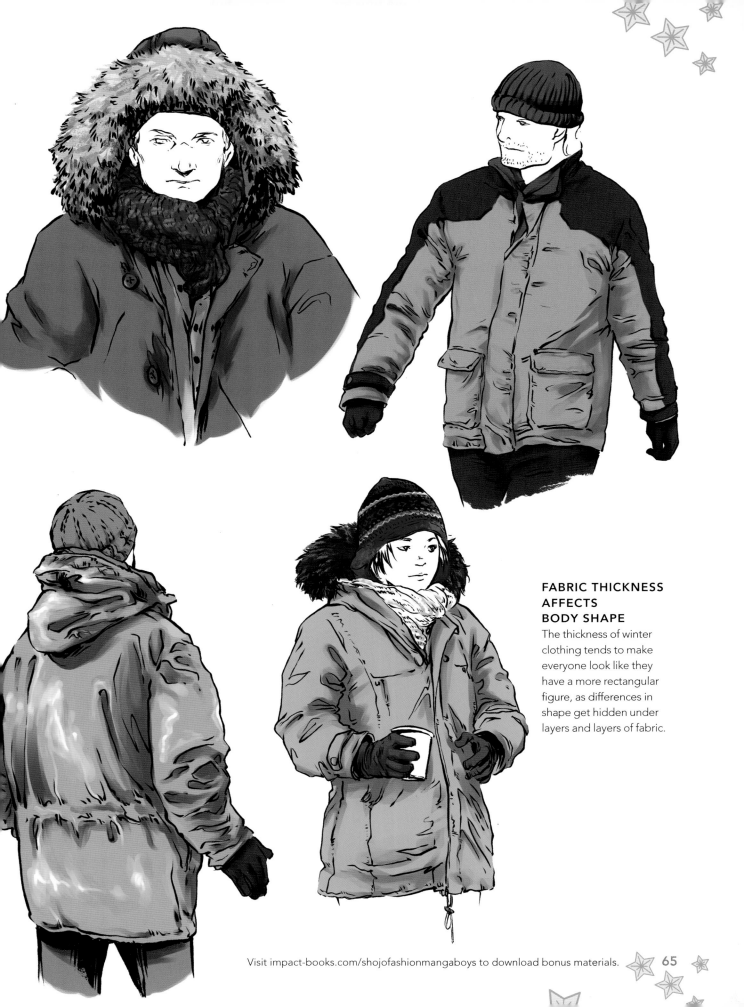

FABRIC THICKNESS AFFECTS BODY SHAPE

The thickness of winter clothing tends to make everyone look like they have a more rectangular figure, as differences in shape get hidden under layers and layers of fabric.

Layers

Layers not only keep you warm, they can also be a great fashion choice. They create more interest than a single t-shirt or sweater alone would.

FABRIC THICKNESS AFFECTS LAYERING

When you layer clothes, make sure that the thickness of the fabric you use still affects the already-existing layers. Here, his outer jacket squeezes down on the fabric of the cardigan on his left forearm.

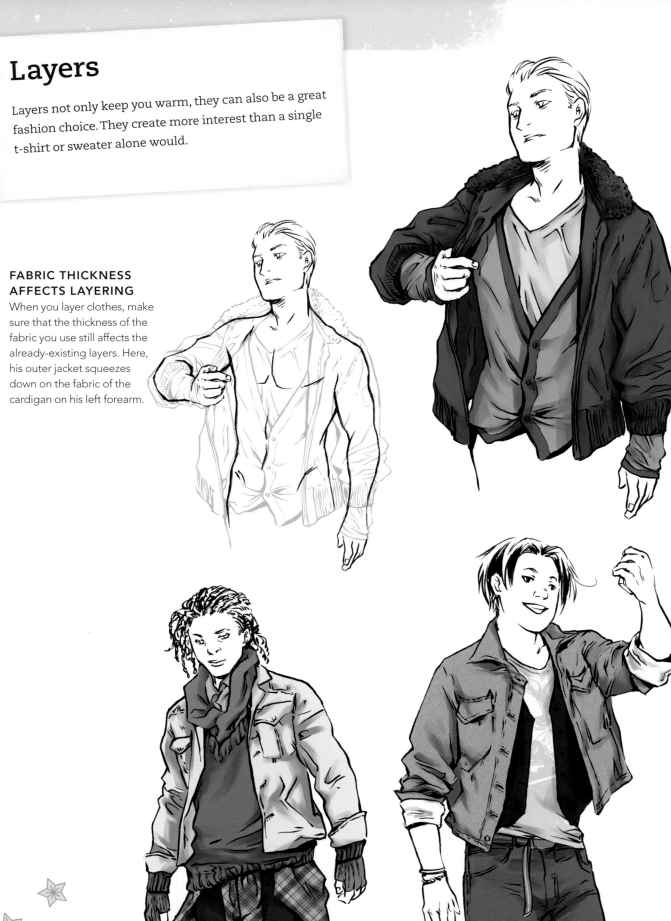

DEMONSTRATION
DRAW LAYERS

Follow the steps to draw layered fabric.

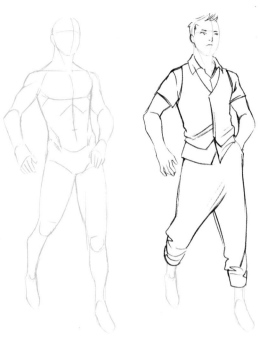

1 SKETCH THE BODY SHAPE
Sketch the shape of the body.

2 SKETCH THE BOTTOM LAYER
Sketch the bottom layer of clothing. Make sure the seams and lines drape and react to the pose appropriately.

3 BUILD UP LAYERS
Keep adding the clothing layers over the existing ones. Those layers will react with the pose as well as the garments already there.

4 CONTINUE ADDING LAYERS
Even though several layers of the clothing won't show after you draw the topmost garment, it's still important to sketch everything so it looks proper, such as the raised shoulders of the coat since there's all that fabric underneath.

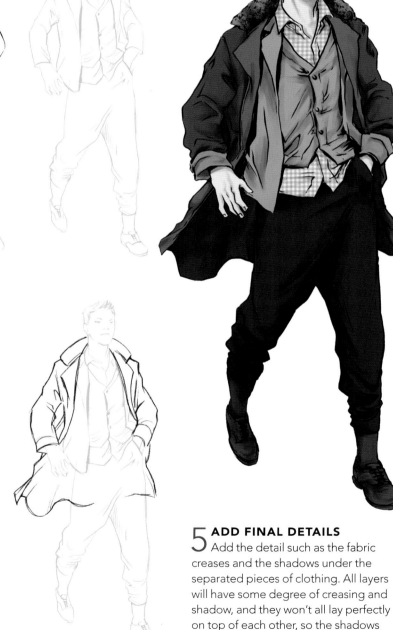

5 ADD FINAL DETAILS
Add the detail such as the fabric creases and the shadows under the separated pieces of clothing. All layers will have some degree of creasing and shadow, and they won't all lay perfectly on top of each other, so the shadows should not be a uniform thickness.

Shorts

Shorts are generally only socially permissible in a casual setting. However, your character may not want to wear anything but shorts! Shorts come in many different lengths, styles and textures.

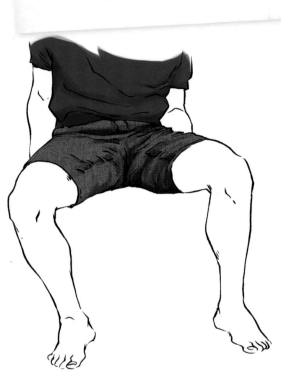

TIGHT SHORTS
Tighter clothing can be easier to draw because the fabric hugs the lines of the body. You just have to add the creases where the fabric is pulled by movement or joints.

LOOSE SHORTS
For looser shorts, make sure that the fabric still reacts to the contours of the body. This means curving around the behind, creases behind the knees and between the legs.

DRAW STUFFED POCKETS

Guys frequently don't carry bags, so instead that stuff goes in their pockets. Follow the steps to draw stuffed pockets.

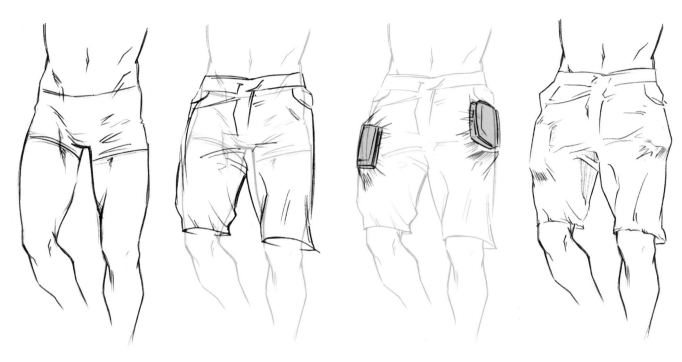

1 SKETCH THE BODY
Like always, begin by sketching the character's body.

2 DRAW THE CLOTHES
Draw the clothing. These shorts are a looser type of cargo shorts.

3 DRAW THE OBJECTS
Draw the objects in the pockets, because they react differently to being shoved in a pocket. The sleek phone slides and rests at the bottom of the pocket, and it's slanted by resting against the thigh. In the left pocket is a bulkier wallet. Its thickness and texture keep it high in the pocket. The red lines show the pull and stretch of the fabric.

4 CLEAN UP AND DRAW CREASES
Clean up the sketch, then draw the creases that appear at the pocket edges. The outline of the objects in the pockets is created by the tight fabric pulled across them.

5 ADD FINAL COLOR
Use color to add more definition of highlights and shadows.

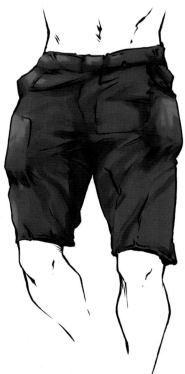

More Shorts

Some types of shorts and pants are pressed or starched when they are cleaned, which is how you get that nice crisp line running down the front of the leg.

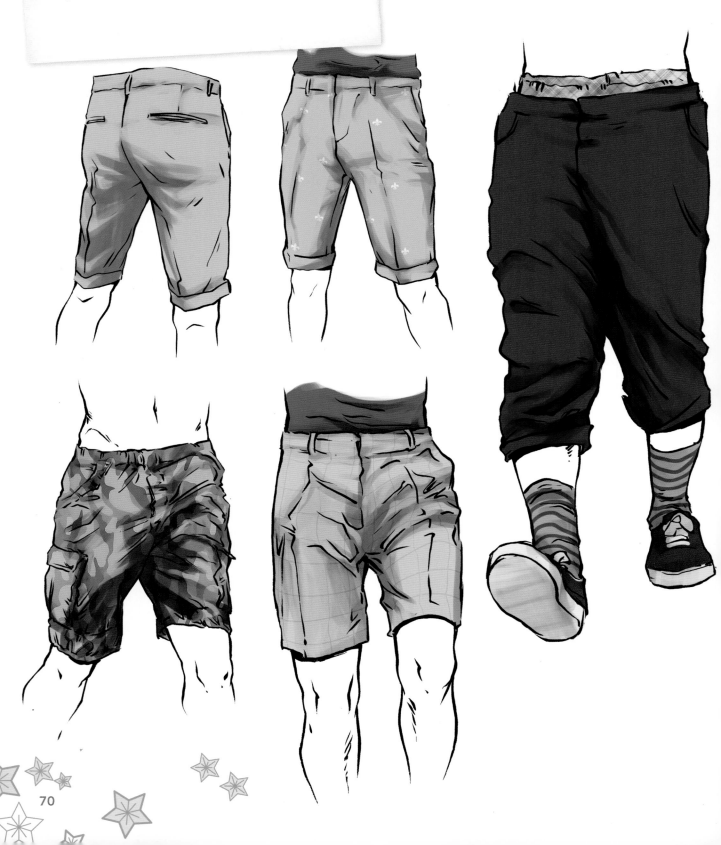

Jeans

Jeans come in various cuts that usually have to do with how high the waist comes up, how loose they are around the hips, and how the fabric is cut from the knee down. Men's jeans don't have as much variety as women's, but they more or less all work the same.

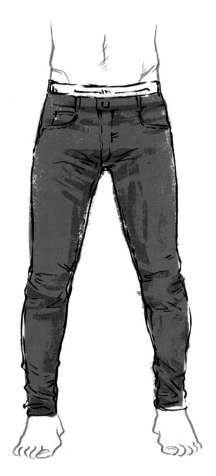 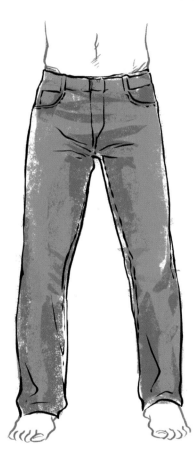 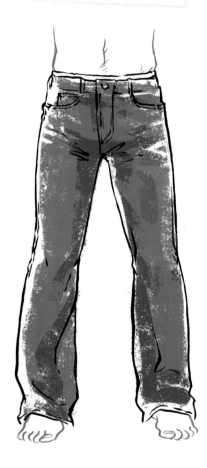

LOW RISE SKINNY JEANS
With skinny jeans, the fabric tapers to hug the calf and ankle.

MID RISE STRAIGHT CUT JEANS
Mid-rise means they sit fairly high on the hips. Straight cut means the fabric falls straight from the knee to the ankle.

MID RISE BOOT CUT JEANS
Boot cut means that the fabric flares out a bit just below the knee to create a wider leg from the calf down, so these jeans can easily slide over boots.

More Jeans

Here are more jeans in various poses to help you get an idea of where creases form and how they sit. One of the key elements to include so that they read as jeans, even in black and white, is the visible stitching on the inner and outer seams. Most jeans also have roughly the same shape of pockets. The back pockets are particularly distinctive.

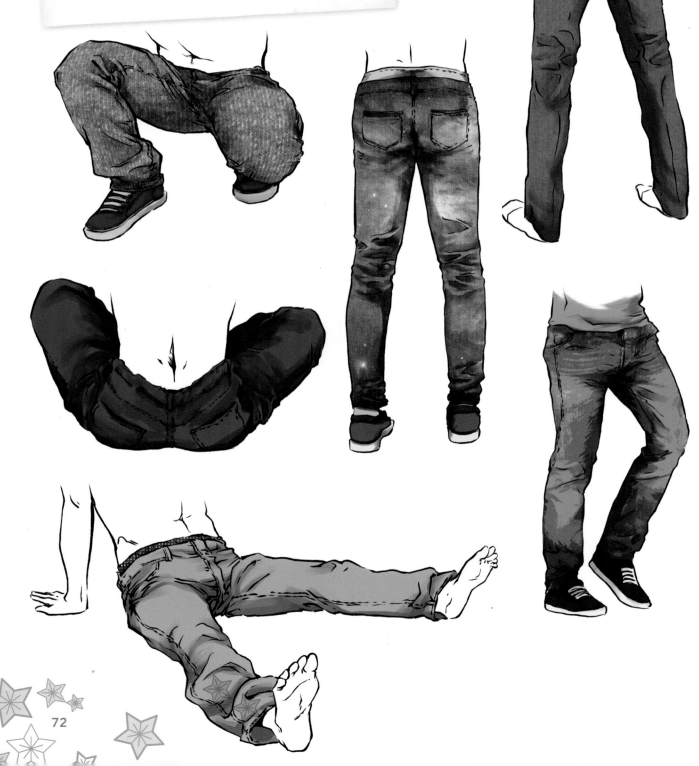

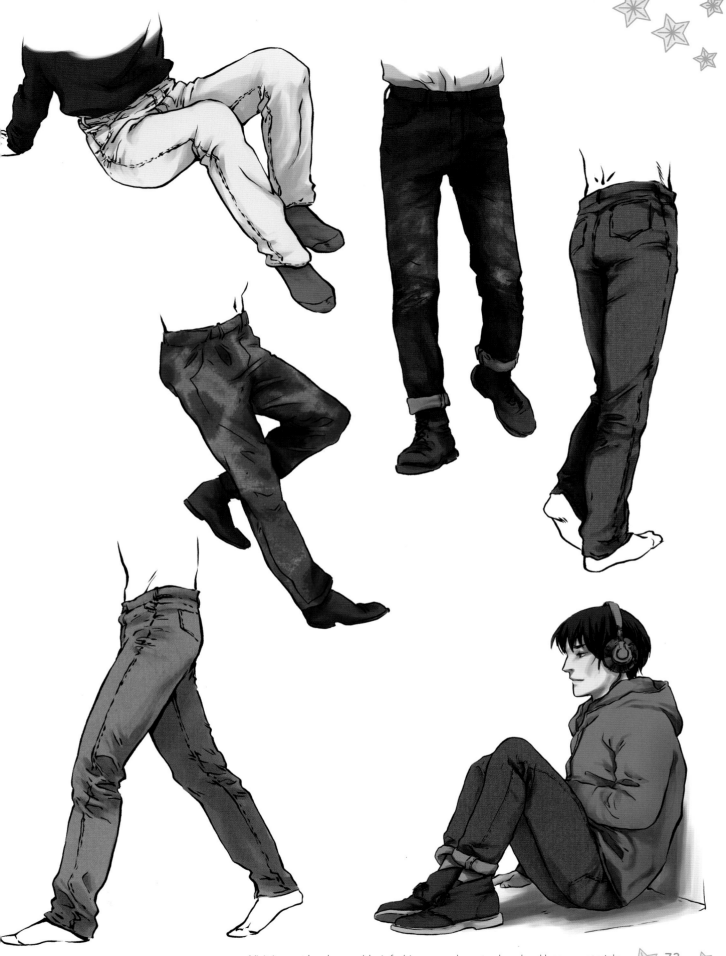

Dress Pants

Like shorts, dress pants usually have an ironed crease down the center of the leg. They also are made from lighter fabric than denim, so instead of bunching up and being stiff, they hang looser around the knees and ankles.

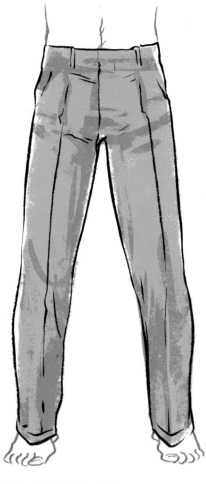

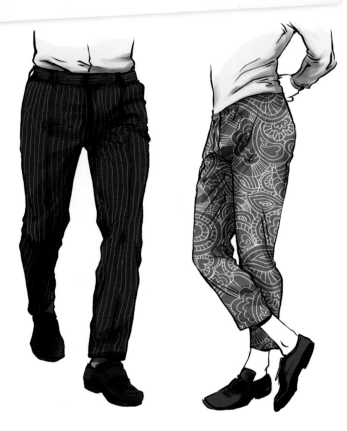

DRAWING DRESS PANTS
The waistline is usually at the belly button, and the fabric isn't as tight at the hips as jeans are. They can also have cuffs at about the ankle, but the cut from knee to ankle is straight.

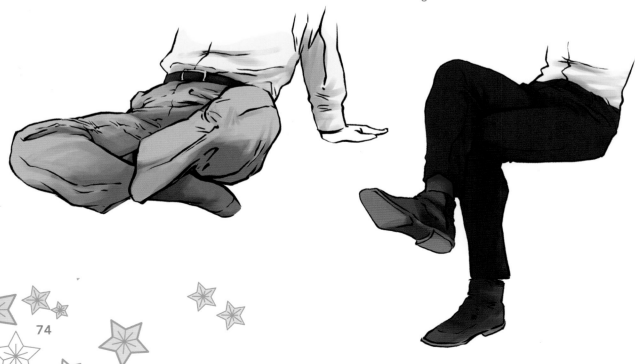

Other Types of Pants

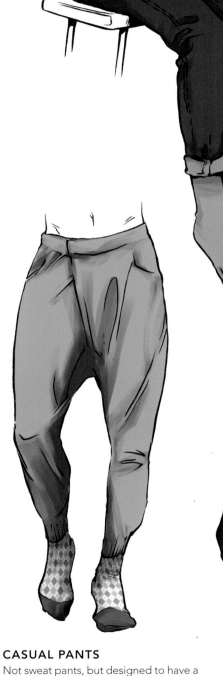

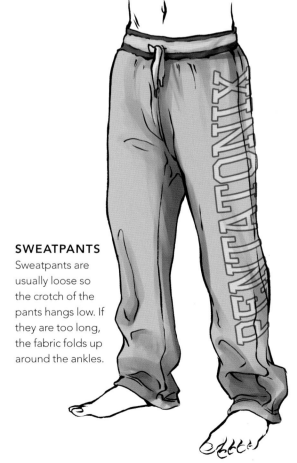

SWEATPANTS

Sweatpants are usually loose so the crotch of the pants hangs low. If they are too long, the fabric folds up around the ankles.

CASUAL PANTS

Not sweat pants, but designed to have a similar bagginess in the hips that results in a low crotch on the pants. Unlike when boys wear their waistband very low on the hips and they threaten to fall off, these are designed to fit securely at the waist.

Waistcoats

Waistcoats are essentially formal wear vests. They are usually worn over a dress shirt, and are great for uniforms as they add an air of formality without being as warm or cumbersome as jackets.

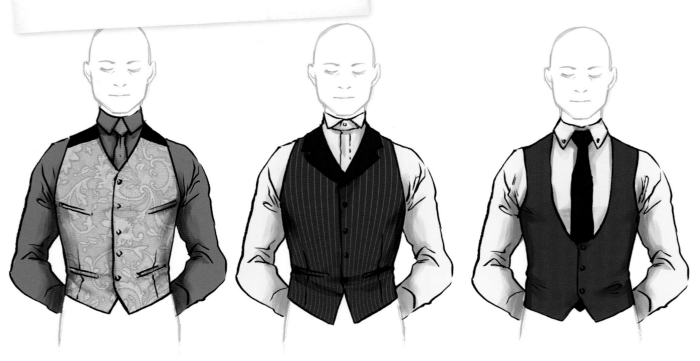

SINGLE-BREASTED WAISTCOATS

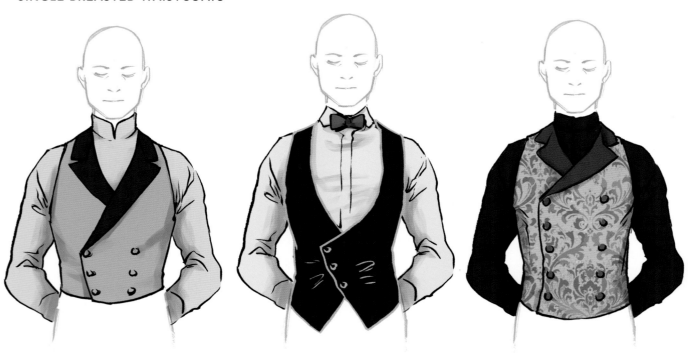

DOUBLE-BREASTED WAISTCOATS

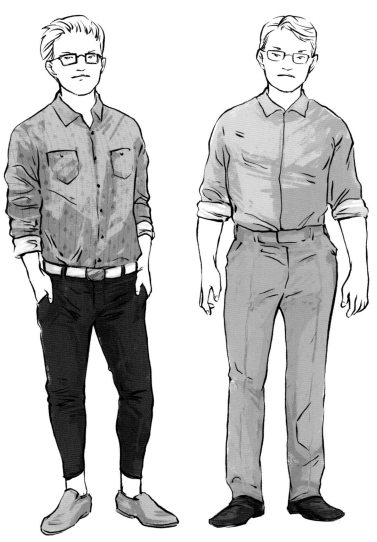

DRESS DOWN

Waistcoats can also be dressed down with a t-shirt or other casual attire.

DRESS UP

Here's an example of what kind of effect dressing a bit differently can have. Same person, but in the second image he's combed his hair a bit differently and put on some less casual attire.

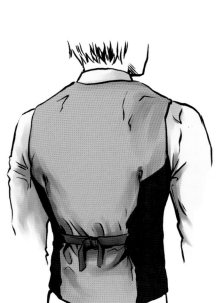

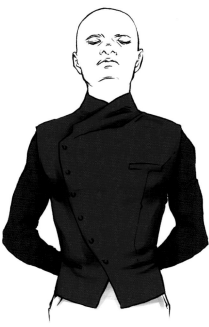

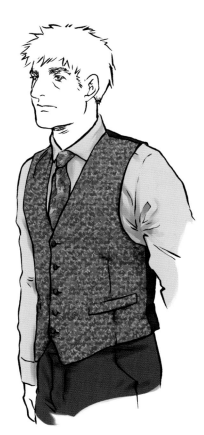

Suits

We spent a lot of time on suits in the previous book, *Shojo Fashion Manga Art School Year 2*, so this time let's take a look at the suit in action.

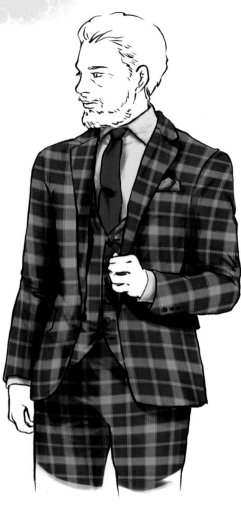

STIFF SUIT
This suit jacket is made of stiffer fabric and is tailored to look sleek, but you can't always draw someone with straight shoulders and their arms hanging down.

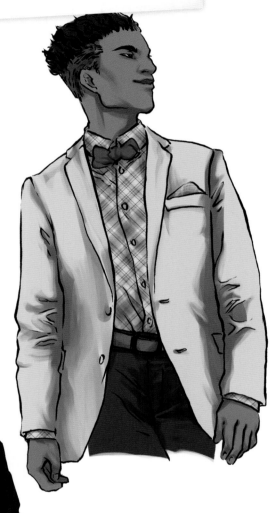

TIES
Remember that unless it is buttoned in, a tie will flap in the wind or hang away from the body if your character bends over.

WRINKLED SUIT
This suit has been worn a few too many times without being pressed. Just making the outlines slightly wavy and adding a few extra wrinkle lines on the suit gives it this rumpled look.

DRAW A SUIT JACKET IN MOTION

Follow the steps to draw a suit jacket in motion.

1 SKETCH THE POSE
Draw a very animated pose. When sketching the button-up shirt, the fabric should be very close to the body, with the garment pulled straight around the torso.

2 BUNCH UP THE FABRIC
The fabric is being stretched between the raised arms and where it's tucked in at the waist so bunch it up around the shoulders. Pull down the cuffs of the sleeves on the forearms.

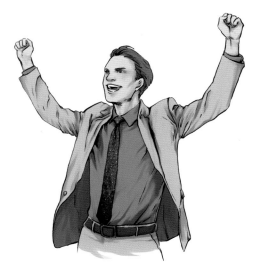

3 CONTINUE ADDING PULLS AND CREASES
When drawing the jacket, the sleeve cuffs tend to be shorter that the button-up shirt anyway, so pull down even more. The shoulders and upper arms are where the tailoring shows. The fabric is ticker, more rigid, so instead of conforming to the curve of the shoulders, the fabric gets pushed up instead.

4 ADD FLARE AND COLOR
The rest of the jacket flares out, following the seams. If it was buttoned closed, the fabric would be pulled up with lines radiating in a V from the buttoned center heading towards the raised arms.

Formal-Wear Accessories

These accessories aren't exclusive to formal wear, but usually add a bit of formality and flare when added to an outfit.

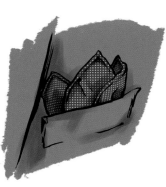
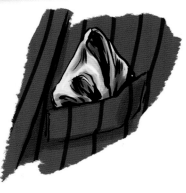
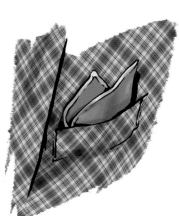

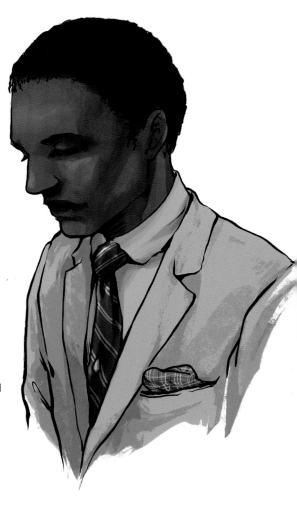

POCKET SQUARE

This is essentially a square of cloth that can be folded and tucked into a breast pocket. They can be folded in a number of ways and add a nice accent color.

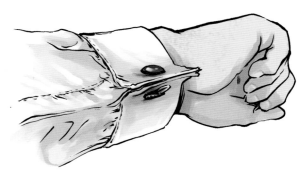

CUFF LINKS

These pin the cuff of a shirt together. Like most jewelry, they can be flashy, subtle, elegant, personal or nerdy.

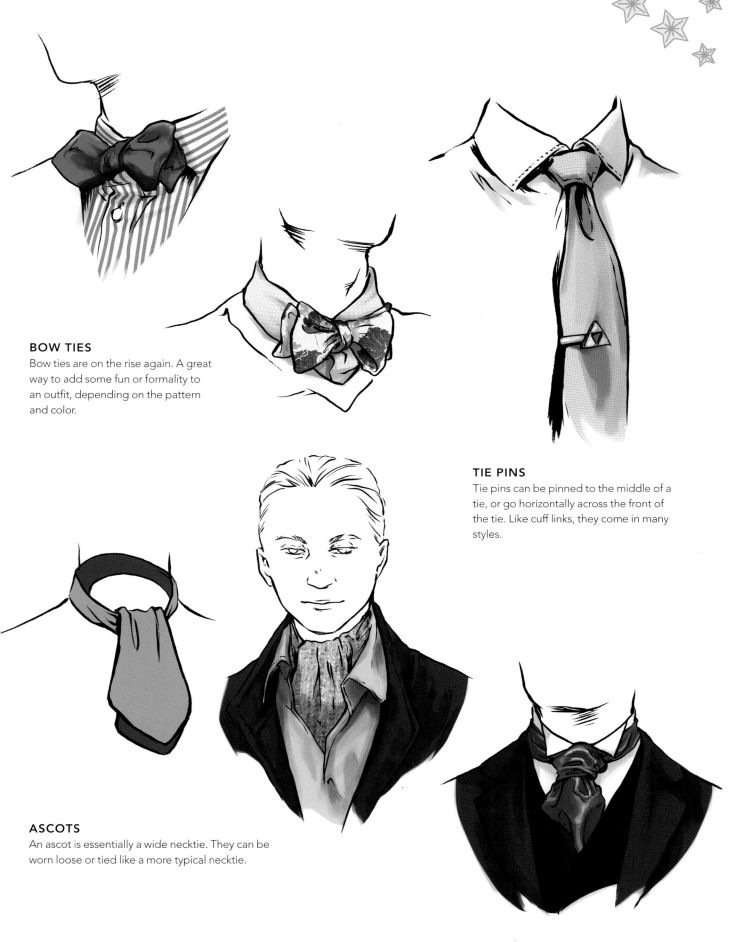

BOW TIES

Bow ties are on the rise again. A great way to add some fun or formality to an outfit, depending on the pattern and color.

TIE PINS

Tie pins can be pinned to the middle of a tie, or go horizontally across the front of the tie. Like cuff links, they come in many styles.

ASCOTS

An ascot is essentially a wide necktie. They can be worn loose or tied like a more typical necktie.

Shoes

Time to dress those feet! It's not uncommon for people to be even more particular about the type of shoes they wear than other clothing, so think about what style suits your character best.

TOE SHOES

FLIP-FLOPS

SANDALS

DRAW DRESS SHOES

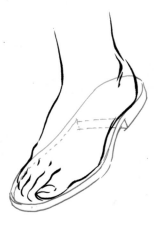

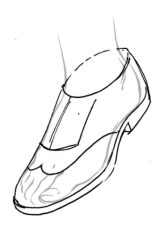

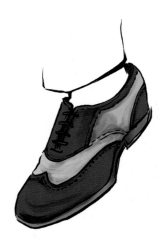

1 SKETCH THE BASIC SHAPES
Sketch the foot and then the sole of the shoe. The sole should be bigger than the foot and have a slightly raised heel.

2 DRAW THE SHOE
If you were drawing flip-flops or sandals, you'd draw out the straps in between the toes. For shoes, encase the whole foot and sketch out the features. Start with the line down the middle of the foot where the laces will go, this acts as a reference point for making sure everything else on the shoe is symmetrical, even when seen from an angle.

3 CLEAN UP AND COLOR
Clean up the sketch and finish it. Remember a lot of fine details aren't about being meticulous and precise. Just a few dots in what is roughly a line will convey stitching without you having to break out any rulers.

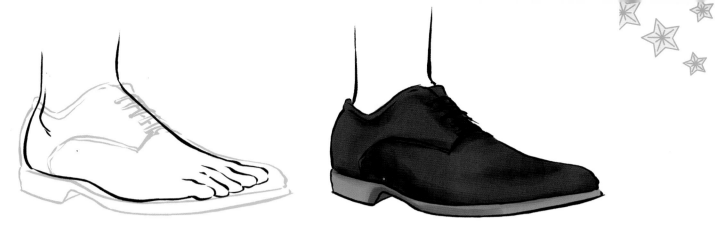

HEELS AFFECT FOOT POSITION

From this angle you can see the way anything with a heel on the shoe is going to reflect on the foot inside.

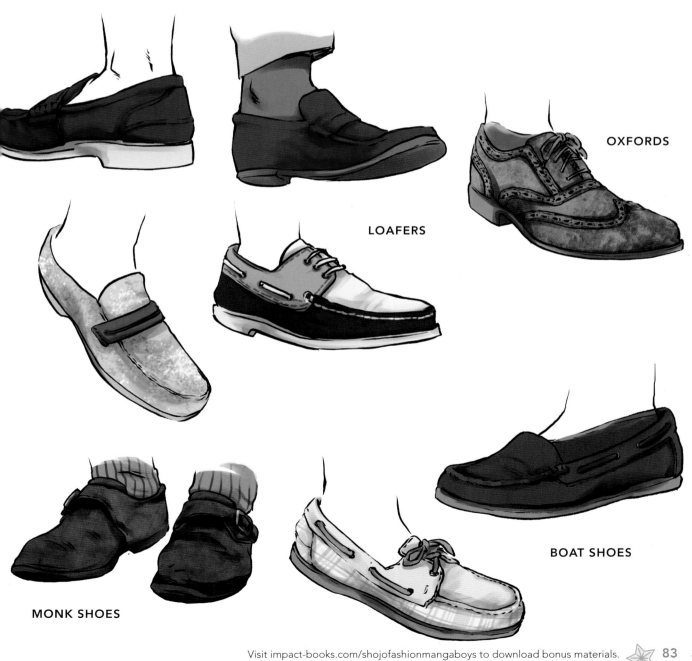

OXFORDS

LOAFERS

BOAT SHOES

MONK SHOES

Sneakers & Boots

Sneakers and boots have the advantage of offering a lot more variety than you can usually find in men's more formal wear shoes. Sneakers in particular can come in tons of colors with logos and designs, and boots come in different styles, with and without fur, zippers, laces, Velcro and various other embellishments.

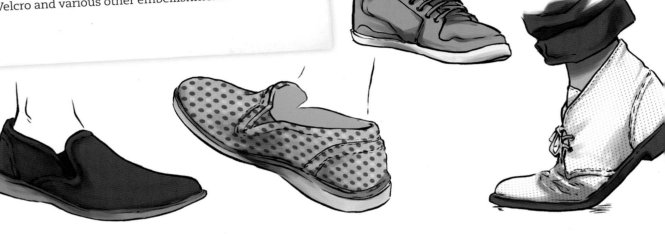

DESERT BOOT
A lightweight boot made from suede fabric.

COMBAT BOOT
Has a thicker sole, a heavier tread and usually goes over the ankle.

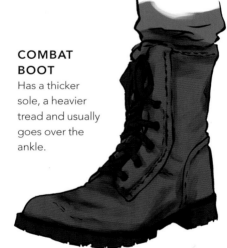

WORK BOOT
Simple and comfortable.

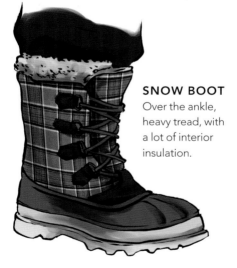

SNOW BOOT
Over the ankle, heavy tread, with a lot of interior insulation.

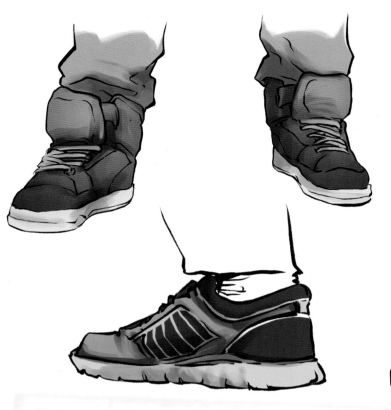

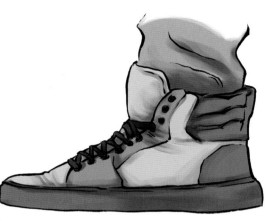

DRAW SNEAKERS

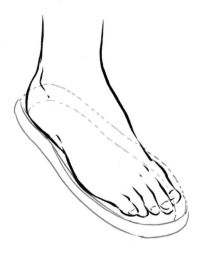

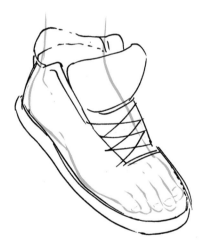

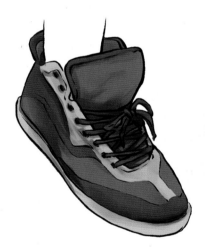

1 SKETCH THE BASIC SHAPES
Sketch the foot and then the sole of the shoe. Start with the sole. Sneakers have a flatter platform with no heel, but it's usually thicker than a dress shoe.

2 DRAW THE SHOE
Most sneakers and sport shoes have more cushioning around the foot than a dress shoe or loafer. Keep this in mind as you sketch the outline around the foot.

3 FINISH WITH DETAILS
Sneakers come in a lot of variety, so do whatever you want. You can add character even with little things like how the shoe is worn. Here the laces don't go all the way up so they have a looser fit; perfect for just slipping on and off.

Hats

These accessories aren't exclusive to formal wear, but usually add a bit of formality and flare when added to an outfit.

KNIT HATS

Knit hats follow the shape of the head. Thickness can vary depending on how insulated you want it to appear. Make use of small and long lines to convey the pattern of the yarn work.

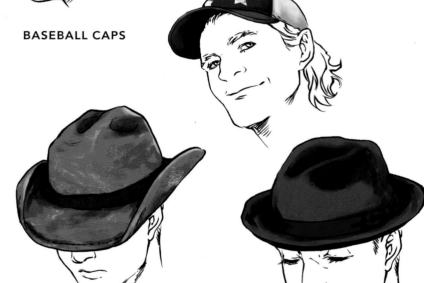

BASEBALL CAPS

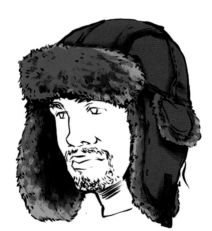

INSULATED FUR HAT

OUTBACK/WESTERN/COWBOY

FEDORA

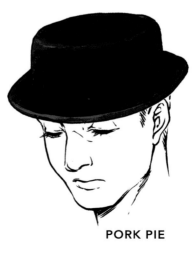

PORK PIE

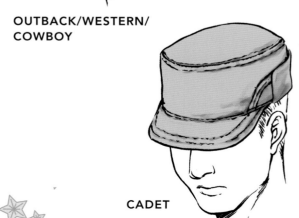

CADET

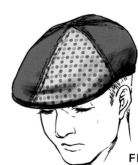

FLAT CAP/NEWSBOY

DEMONSTRATION
DRAW A HAT

Follow the steps to draw a hat.

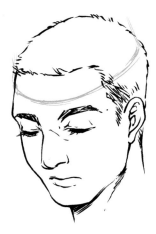

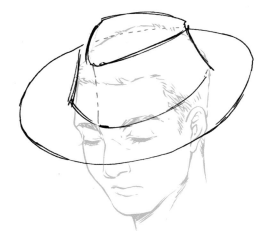

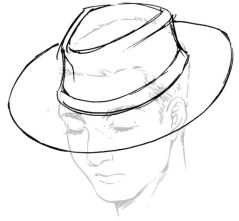

1 SKETCH THE BASIC SHAPES
After drawing the head, sketch an oval where the hat will sit on the head.

2 BLOCK IN THE HAT
The top of this hat comes to a slight point at the front, so use the center of the face to draw a guideline for where that point should come to.

3 ADD DETAILS
Don't forget that hats have seams and stitching too. There should be a thickness where the fabric folds or meets another piece of fabric, or it will look flat.

4 CONSIDER MOOD AND COLOR
Be aware of what the hat brim will hide. This can add to the mood of your character, but if you don't plan ahead it might not be the mood you want.

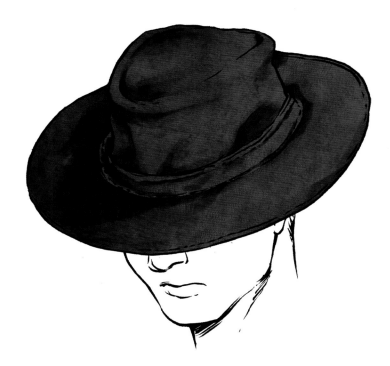

Scarves, Gloves & Glasses

Scarves, gloves and glasses are some common accessories you can use to snazz up any character design.

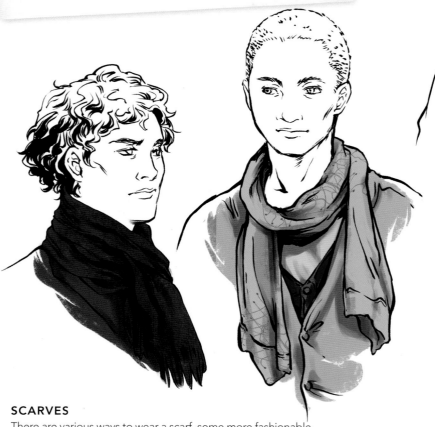

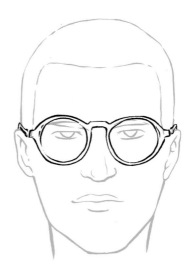

SCARVES
There are various ways to wear a scarf, some more fashionable, others better at combating the cold.

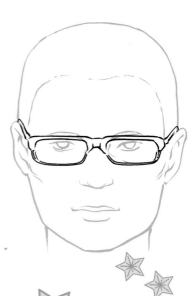

EXPERIMENT WITH DIFFERENT STYLES OF GLASSES
Experiment with what style of glasses you think looks best on your character. Some styles tend to better fit different face shapes, such as longer rectangular ones for wider faces. You also want to think about what style your character would aim for.

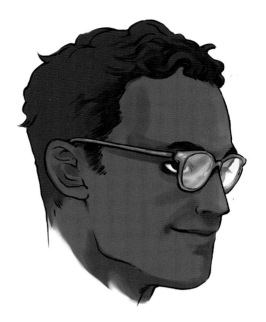

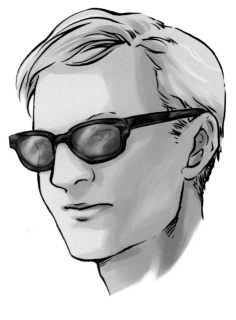

DRAWING GLASSES FROM AN ANGLE

Drawing glasses at an angle takes a little more practice. Remember that parts of them are going to disappear behind the nose and the brow.

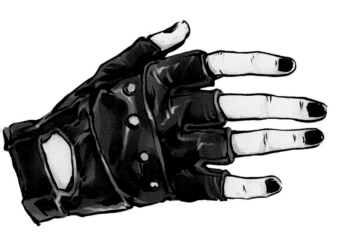

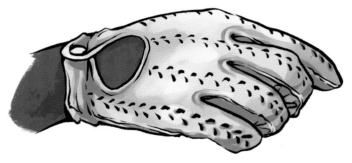

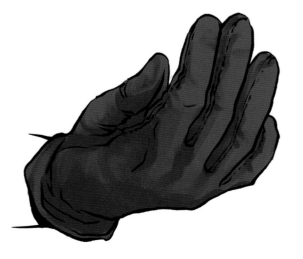

GLOVES

Gloves can be worn for warmth, fashion, work and recreation. Just keep in mind what they'll be used for; from gardening to construction, riding dressage or riding motorcycles.

5 | Cool Looks & Scenes

So far we've been talking about all the different ways you can use design, body type and wardrobe to create a character others can recognize, invest in and identify with. In this chapter, we bring all of that together to show off a cast of diverse characters that hopefully will inspire you to do the same! We'll also cover drawing characters together, how they interact with and react to each other, and how you can set it all into a scene.

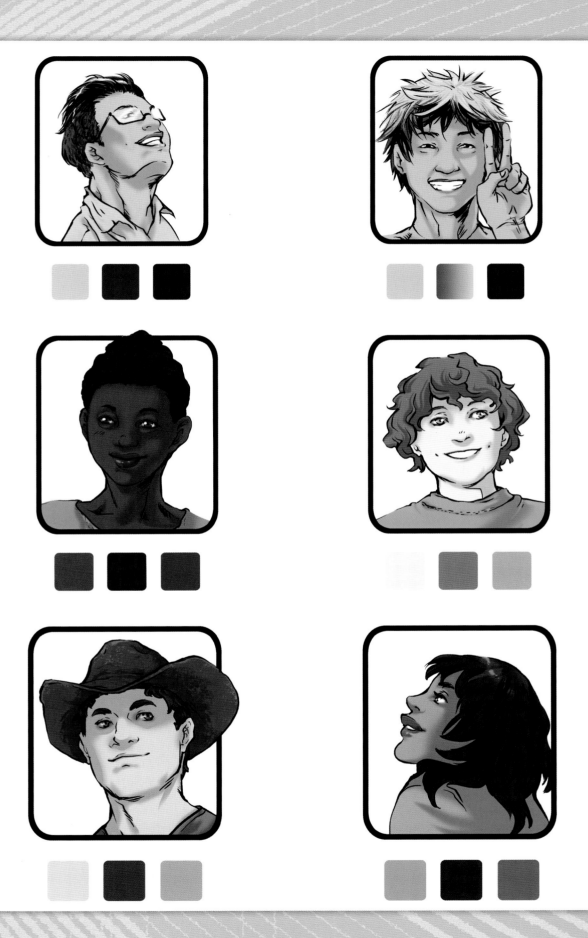

TREVOR WILLIAMS

Not the type to mince words, Trevor thinks of himself as a simple guy. He's naturally the harmless and easy going type, and was bullied a lot before his growth spurt hit. Now he has a bit of a temper that was instilled in him by his protective younger sister, Beck. As long as it isn't malicious, he'll put up with any amount of teasing, even about his hat, but as soon as someone starts to get mean with him or anyone he cares for, Trevor is ready to teach them that the best defense is a good offense.

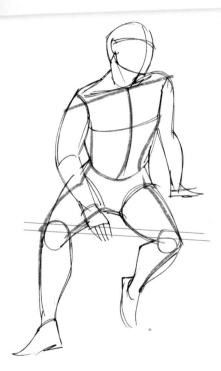

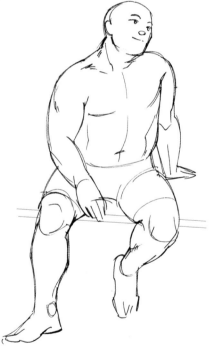

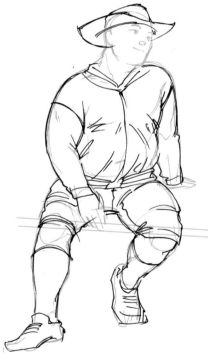

1 STRIKE A POSE
Start with a rough sketch of the pose. Trevor is a pretty relaxed guy so make sure his weight is leaning on his left arm, with the right one resting easily on his thigh. Since you know what body type you want to aim for, start with already wide proportions.

2 FILL IT IN
Time to rough out his body type and facial features. The fat means you can't see much muscle definition, but muscle means the fat doesn't hang in rolls. The result is just an all around bulky guy. His frame is affected by pose and clothes; notice how the tighter pants cinch in at the waist and the navel is looks squashed.

3 ROUGH IN CLOTHING
Now rough in the clothes over the body. The creases in the letter man jacket are rounded over the stomach, and there are pads inside the football uniform pants that make a visible rectangle on his thighs.

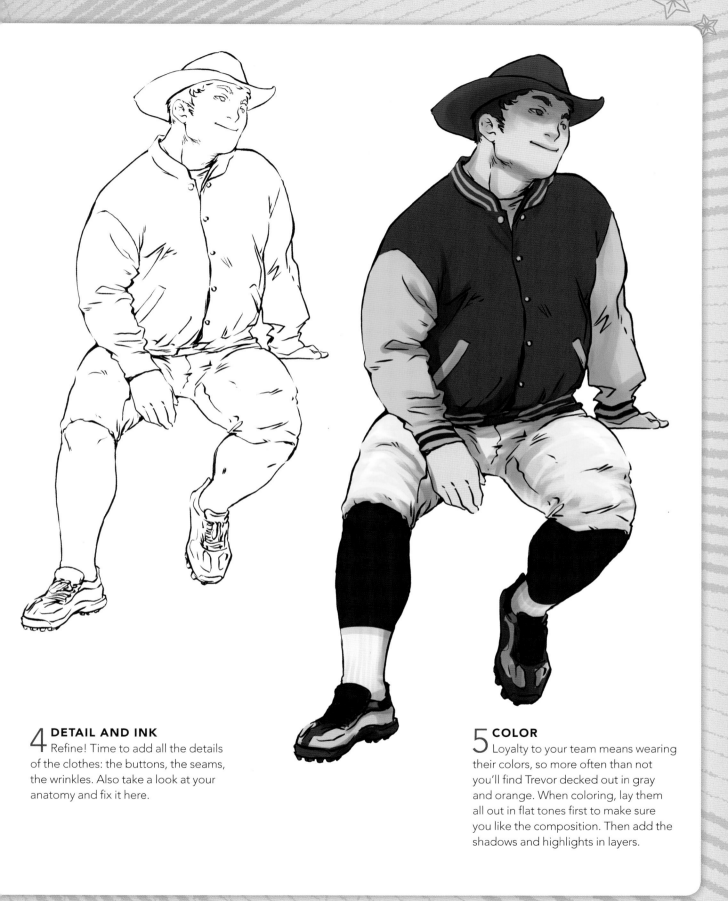

4 DETAIL AND INK
Refine! Time to add all the details of the clothes: the buttons, the seams, the wrinkles. Also take a look at your anatomy and fix it here.

5 COLOR
Loyalty to your team means wearing their colors, so more often than not you'll find Trevor decked out in gray and orange. When coloring, lay them all out in flat tones first to make sure you like the composition. Then add the shadows and highlights in layers.

JULES MASONSON

Despite a seemingly unlimited amount of creative energy that he pours into the writing and design of tabletop campaigns, Jules is just not what you would call a people person. Though, in his defense, he really isn't trying. Jules knows who he is and what he wants, and that list tends more toward players in his games than casual or not-so-casual acquaintances. But if you can tolerate his frequent and lengthy diatribes on who-did-what-wrong, followed by bouts of brooding silence, you'll find someone with loyalty, honesty and a good sense of humor, who is actually fairly easily bulldozed into doing you favors.

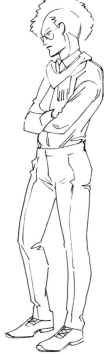

1 STRIKE A POSE
Sketch the pose. Jules is tall and skinny, but stands with a notable slouch. He's also not the friendliest, so give him a closed-off posture.

2 FILL IT IN
Add body detail. His weight is on his left leg so the muscles there are more contracted. Everything else is pretty loose. He's got some wiry muscle, but not a lot.

3 ROUGH IN CLOTHING
Even though this will finish with him wearing a coat, rough in the clothes underneath first. This helps make sure any layers drawn over it hang correctly, and if you're going to draw him repeatedly, it's good to know what he's wearing when he takes his coat off.

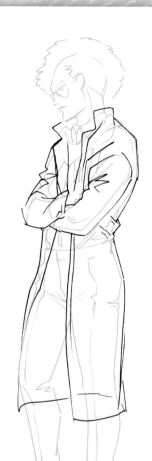
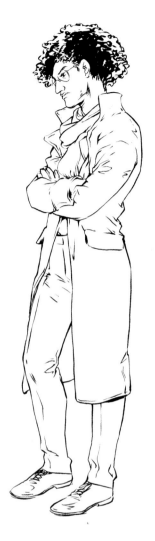
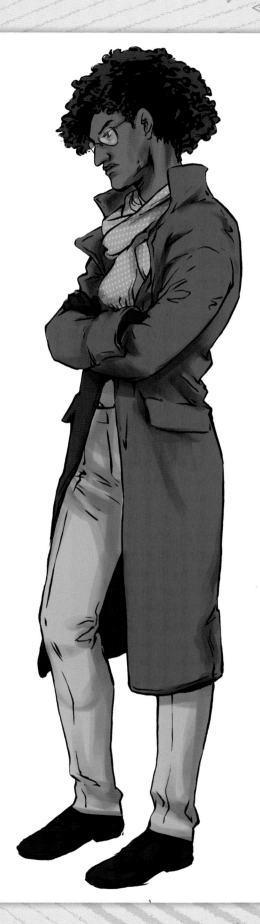

4 DRAW THE COAT

Draw the coat over the clothing beneath. Since the dress pants and shirt fit well, there isn't really that much added bulk.

5 DETAIL AND INK

Time for details. Make sure everything looks just right. (The scarf was fixed so that it hangs between the coat lapels.) Add cuffs and pockets to the coat.

6 COLOR

Jules isn't adverse to color, but gray goes with everything, so the bulk of his wardrobe is neutrals. This means when he does throw on a colored shirt or scarf, it goes fine without him having too worry much about this fashion business.

RODRICK FLORES VALDEZ

Physically active, emotionally relaxed, frequently charming, and just a little bit distant, Rod has the tendency to ignite a little crush in everyone he meets. Something he is perfectly well aware of, if never quite sure how to deal with. His interests lay less toward wooing any potential suitors and more toward scaling the nearest rugged terrain on foot or in his ATV, or possibly just flopping back on his couch to listen to some classic rock from his collection of vinyl.

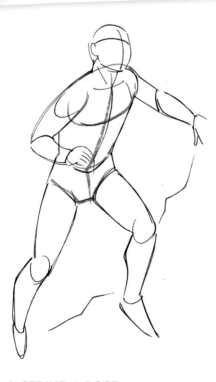
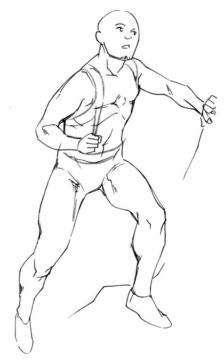
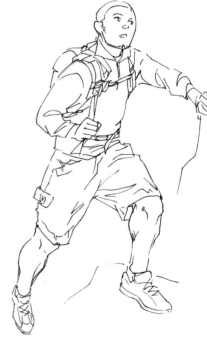

1 STRIKE A POSE
When sketching out the pose, fore-shorten it a little because the right leg is hanging lower than the rest of the body as he climbs up.

2 FILL IT IN
Rod has a more rectangular body type. His shoulders are about the same width as the hips, without much of a dip for the waist, but it's mostly muscle. There are lots of angles since he's using those muscles.

3 ROUGH IN CLOTHING
Time to rough in the clothes and accessories. The shorts are pulled tight against the top of his left leg and the back of his right, stretching the fabric with his long stance.

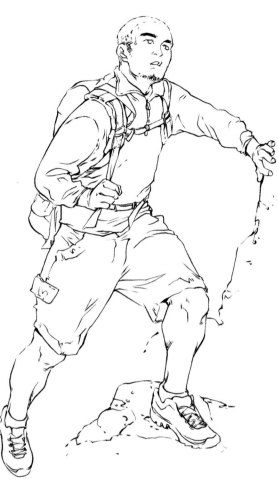

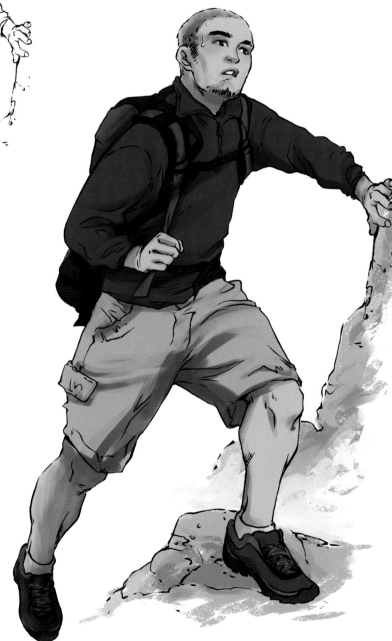

4 DETAIL AND INK
Add the details. Even though the clothes are fairly baggy, you can still get a sense of how fit he is from how muscled his calves are. This guy must hike a lot!

5 COLOR
When dealing with something like a sheer cliff face, you want to be careful to keep the direction of the sun in mind. If it's sunny the light is going to reflect brightly off the stone. If he's in the shadow of the mountain, the shot will be a lot darker.

ROY MERCADO

Who says class clowns will never succeed in life? Common wisdom fails epically when it comes to Roy, who is almost as full of charm and gentle mockery as he is an insatiable passion for coffee. Working to take over his family's beach-side coffee shop, he's been hooked on the stuff since pre-puberty and says he isn't holding a grudge over the waste it laid to any potential growth spurt.

1 STRIKE A POSE
Start with a playful finger gun pose and contrapposto stance.

2 FILL IT IN
Rough in the body type. Roy is short but with an average build. His legs are a bit longer than his torso but not by much.

3 ROUGH IN CLOTHING
Start adding the outfit. He looks like the type with a lot of personality, so put that in his clothes, too! Thick half-frame glasses, rolled up pant cuffs... and he's the type to wear shoes with lifts.

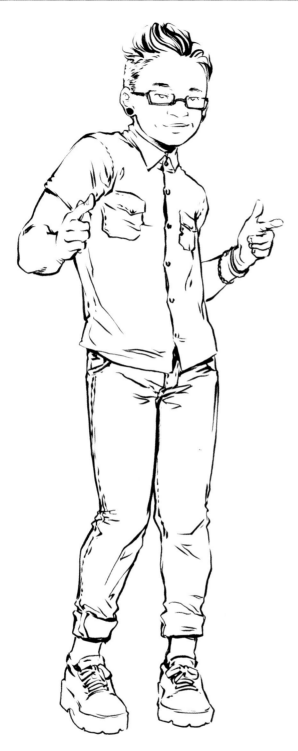

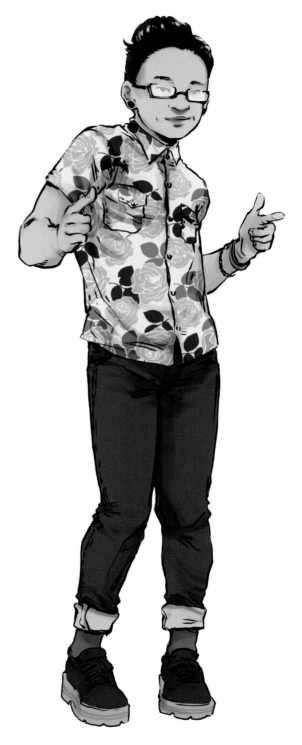

4 DETAIL AND INK
Add detail to the facial features. You can go from very generic facial feature placeholders and add little details to signify specific racial backgrounds.

5 COLOR
It's not that Roy puts a lot of thought into his wardrobe, it's just that he shamelessly puts on whatever he likes—and he likes bright colors, jewelry and close-fitting fabric.

JEREMY McFADDEN

The quiet type with a sharp wit and sometimes surprisingly sharp tongue, Jeremy is as much a craftsman at conversation as he is at knitting (and crochet, and wirework, and some painting…). He is more of a listener than a talker, but his observations are always on point and sometimes cutting— only to provide the most honest and helpful feedback to his friends, of course.

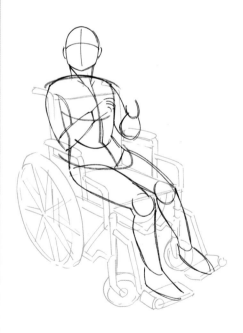

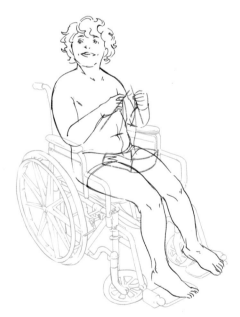

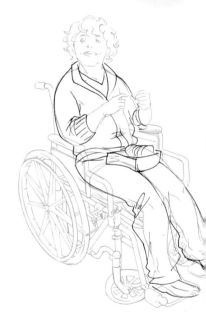

1 STRIKE A POSE
You want to sketch out the wheelchair along with the pose. You don't need to do as much detail as I did, since a lot of that won't show, but get enough in there that you have the proportions of the wheelchair figured out, so nothing is misplaced later.

2 FILL IT IN
Jeremy has a slightly chubby body, so adjust his pose and proportions a bit as you add bulk. This is also a good point to detail in the chair and account for other props like his knitting needles, which will help you pose his hands.

3 ROUGH IN CLOTHING
Rough in the clothes. He's wearing something comfortable and a bit baggy, so you can now pretty much only tell what his body shape is by the way his upper arms are a bit thick.

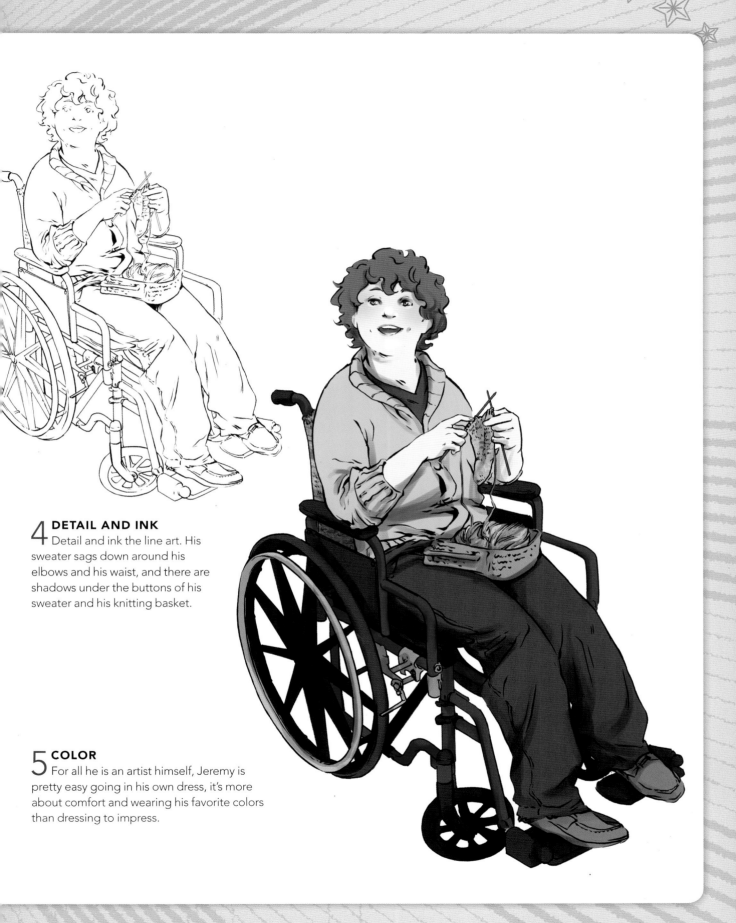

4 DETAIL AND INK
Detail and ink the line art. His sweater sags down around his elbows and his waist, and there are shadows under the buttons of his sweater and his knitting basket.

5 COLOR
For all he is an artist himself, Jeremy is pretty easy going in his own dress, it's more about comfort and wearing his favorite colors than dressing to impress.

BRIAN FENG

Usually known only as Feng, which is what happens when you have approximately one million siblings; strangers and friends alike start to consolidate you into one easy-to-remember name. Which is just fine by him, as Feng's exactly as easy going as he looks. Not the type to get his feathers ruffled by much of anything, Feng works part-time at the beach, teaching youngsters and tourists the basics of surfing, and divides the rest of his time between helping with his siblings, naps and keeping Roy and Patty from coming to blows on the subject of coffee vs tea.

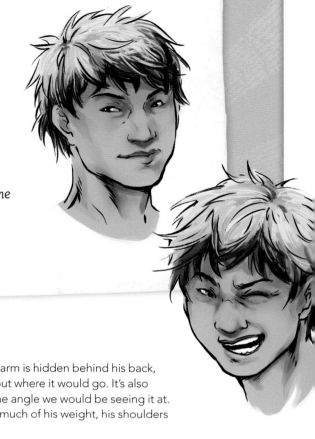

1 STRIKE A POSE
Sketch the pose. His left arm is hidden behind his back, but you still want to sketch out where it would go. It's also foreshortened because of the angle we would be seeing it at. Since his arms are taking so much of his weight, his shoulders rise up in response.

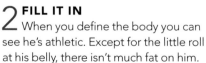

2 FILL IT IN
When you define the body you can see he's athletic. Except for the little roll at his belly, there isn't much fat on him.

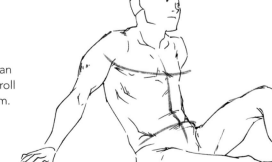

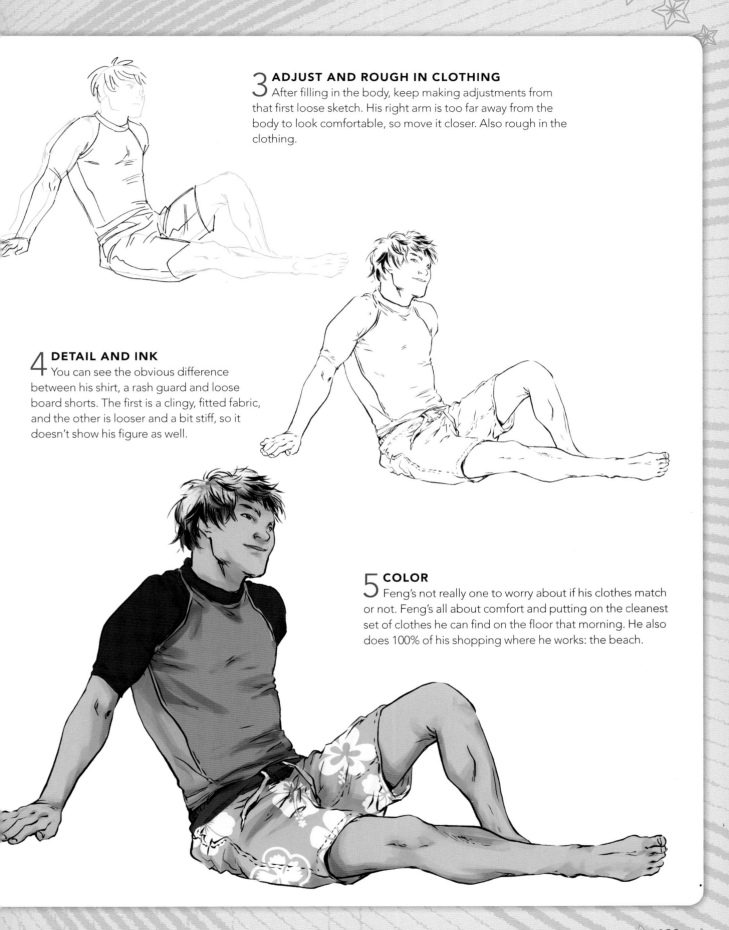

3 ADJUST AND ROUGH IN CLOTHING

After filling in the body, keep making adjustments from that first loose sketch. His right arm is too far away from the body to look comfortable, so move it closer. Also rough in the clothing.

4 DETAIL AND INK

You can see the obvious difference between his shirt, a rash guard and loose board shorts. The first is a clingy, fitted fabric, and the other is looser and a bit stiff, so it doesn't show his figure as well.

5 COLOR

Feng's not really one to worry about if his clothes match or not. Feng's all about comfort and putting on the cleanest set of clothes he can find on the floor that morning. He also does 100% of his shopping where he works: the beach.

ALEXIS JONES

A dancer of ballet and contemporary, to see her on the stage you wouldn't guess that Alexis is usually the type to stay at the back of the crowd or find herself a quiet corner in the unlikely event she somehow wanders into a party. But everyone finds different ways to express themselves, and for Alexis it was dance. Whether it is under a spotlight or during hours of grueling practice, she tackles any challenge with exuberance that pulls others along as much as it gets her through. Too bad she still hasn't figure out how to do apply that energy and confidence anywhere else! Right now she's still working up the confidence to ask a certain barista for more than just a cup of coffee.

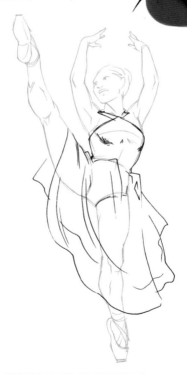

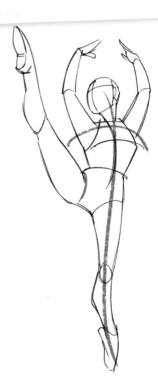

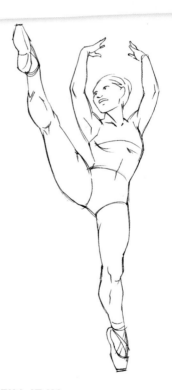

1 STRIKE A POSE
Don't be afraid of more extreme poses. The human body is amazingly flexible, and if you're ever doubting yourself, look up some references in books or online. This is especially helpful for something like ballet, which has pretty specific positions and poses.

2 FILL IT IN
Alexis has a lot of muscle from years of dance. She is also short, so it makes her look fairly stocky. In this pose, you can see more muscle definition in the left leg, since it's holding all the weight.

3 ROUGH IN CLOTHING
Rough in the clothes. The top is stretchy and form fitting, but the skirt is light and airy. It seems to float away from the body.

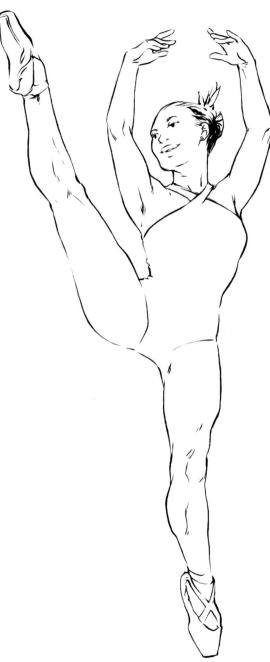

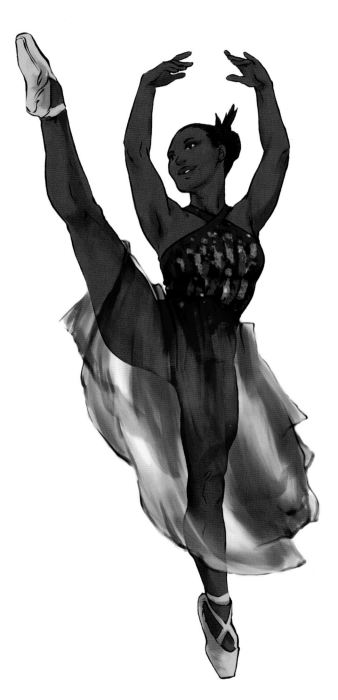

4 DETAIL AND INK
The leotard is form fitting, and you also want her to look very elegant, so don't draw in fabric creases except for the little bit where her waist bends as she lifts her right leg.

5 COLOR
For her skirt, don't use inked lines. Showing that the garment exists by coloring, along with making it transparent, gives it a much lighter feel.

 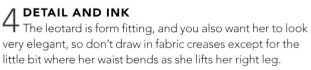

CHARLIE GELLER

Have you ever known exactly who you are and what you want to do and what you need to achieve to get there? If so, you already have a lot in common with Charlie. She's going to be a director, a famous one, but probably not for another fifteen years. It's okay, she's going to pace herself realistically, because there's not much space in her lifelong plan for shattered illusions. When not directing small community plays in or out of her university, Charlie is doing everything for the show that isn't directing: acting, choreography, costumes, sets, lighting. Currently she admits to being a jack-of-all-trades, but figures that if she keeps up at this rate, she will be a master-of-all in due time.

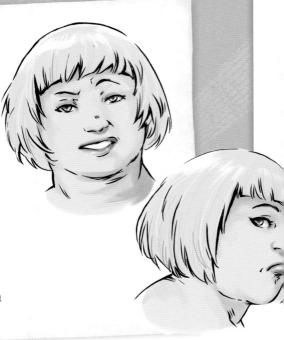

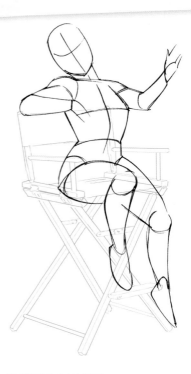

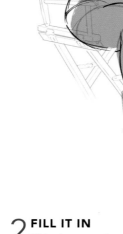

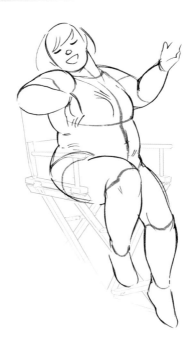

1 STRIKE A POSE

Reference a director's chair and draw its lines first. Work the character sketch on top of it. Since the object is pretty rigid you'll have to work your way around it.

2 FILL IT IN

This character has a lot of weight, so draw that over the smaller frame. People carry their weight in different places but to some extent, fat will always be spread across the entire body, so even her feet and hands are going to get a bit larger.

3 CHECK PROPORTIONS

Use red lines for reference points so it's easier to make sure you haven't lost track of proportions and the body's symmetry.

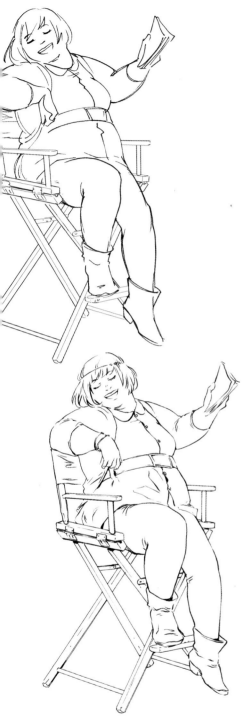

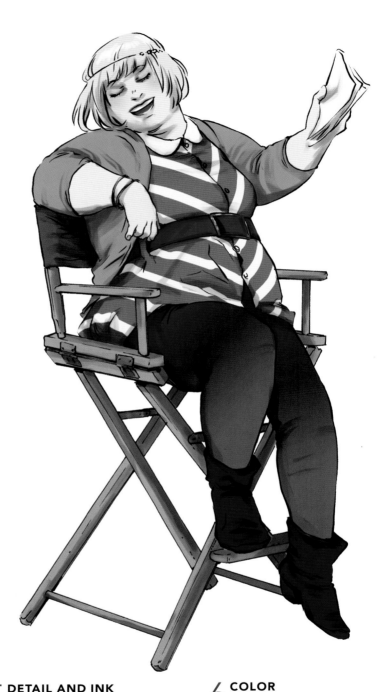

4 ROUGH IN CLOTHING

Time to start roughing in clothing. She is dressed in well-fitted clothing, so there isn't a lot of stretching. The back and the seat of the chair are made from a stiff fabric, so it stretches a bit but not much.

5 DETAIL AND INK

You can design clothes to make them look flattering or not. The belt defines the waist and adds some detail that breaks up what would otherwise look like a too-large expanse of fabric. With the chair, add some shadow and imperfections; little nicks and varying line weight will make it look used.

6 COLOR

Charlie definitely puts a lot of thought into what she swears, from the slimming V pattern of her top to subtle use of accessories. Also, don't forget that leggings can be fun and colorful as well, even though a solid dark color is the standard, there's no reason they can't come in as much variety as any garment.

PATIENCE "PATTY" WASHINGTON

Patty is engaged in a long term, faithful relationship with her high school sweetheart; the vintage junker she's been fixing up since her mother gave it to her as a graduation gift. This is proof by itself that Patience wasn't the wrong name for her, no matter how many times she gets into heated tea vs coffee battles with her childhood friend, one Roy Mercado. It's just that she only has patience for things worth her time: friendship, cars, family, cars, the beach, and also all of those things when in, on, or around cars.

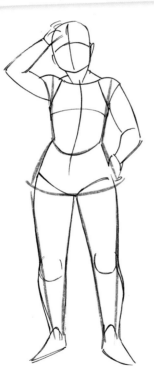

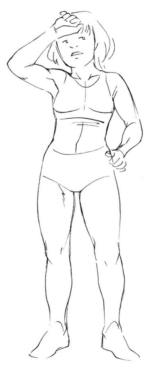

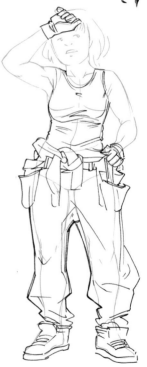

1 STRIKE A POSE

Sketch. You can already get a feel for the personality; strong, solid pose, both feet planted on the ground. There's a bit of a relaxed slouch.

2 FILL IT IN

When you define the features, think about varying your body types. She has wide hips, thicker legs, and her waist isn't very narrow—all of which gives her a stockier appearance.

3 ROUGH IN CLOTHING

The coveralls are baggy, but it's still important to draw the legs underneath to make sure that even though the fabric bunches up in places and doesn't go through the legs. On looser clothes like these, the crotch of the pants hangs pretty low, which makes her legs look even shorter.

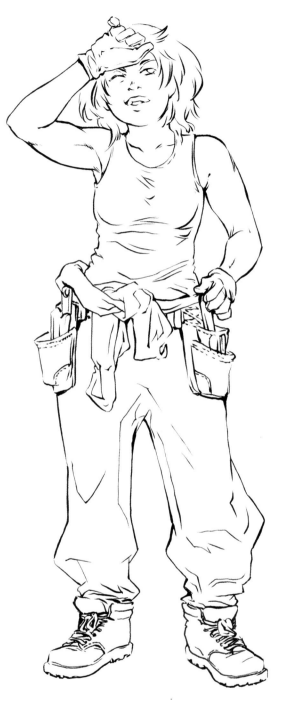

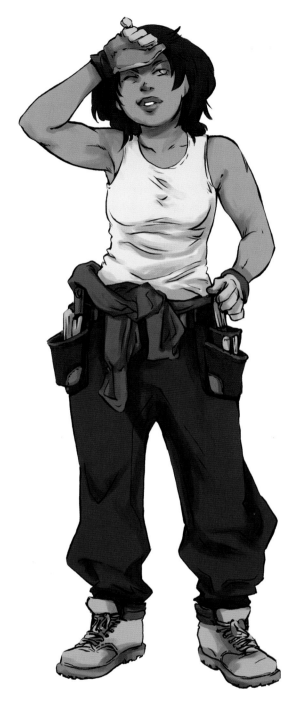

4 DETAIL AND INK
Clean up the lines and define the details. Make sure all the clothing is interacting with each other properly. Here you can see the way her tank top hits the ridge of her tool belt, and coveralls get caught hanging on top of tools.

5 COLOR
When you're doing grease smudges, don't just throw them on anywhere unless you want it to look like your character has a lot of accidents in the shop.

CHOOSING ANGLES

Once you have a fabulous cast of characters sometimes you're going to want to do a dynamic group scene. This means putting in a little extra care and planning so that your scene reads well to the viewer and doesn't have any obvious inconsistencies. When you pick the angle of a scene, you want to think about the composition of your piece; not just what you are going to draw, but how you want it to read. This time I'm looking to draw seven friends and it should be clear they are having a good time.

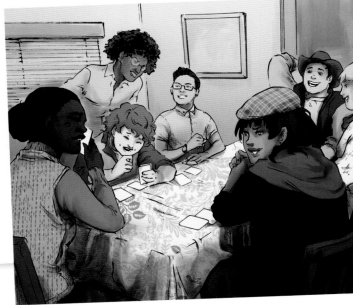

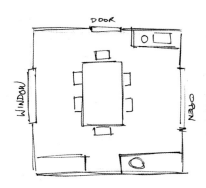

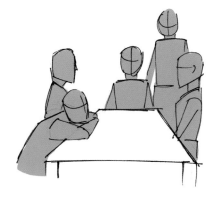

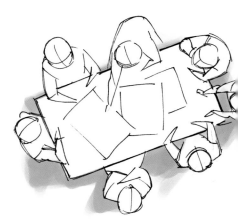

1 SKETCH
First, do a quick sketch of the room. This doesn't have to be too detailed; it's just a guide so you know what furniture, doors, windows etc are going to be visible from whatever angle you choose to draw from.

2 EXPERIMENT WITH AN ANGLE
With this angle, the table view and straight-on perspective make it very symmetrical and kind of formal. The eye will be drawn to the person at the head of the table, making them seem like the focal point. You want to make everyone seem as equally important as you can, but with this angle it's hard to even show all their faces.

3 TRY A DIFFERENT ANGLE
This angle would show everyone equally, but you won't really be able to see their expressions, which I want to highlight. This kind of angle would be more ideal for drawing attention to whatever is on top of the table, like plot relevant battle plans.

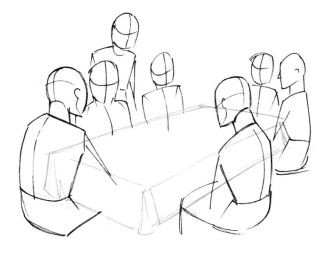

4 ROUGH IN THE CHOSEN ANGLE

This angle is the one you'll want to use. With just a little work, you can see everyone's face. And since the character's closest to viewer are also facing slightly away, it doesn't give the impression they are more important than the other characters. Because it's an asymmetrical table from the reader's point-of-view, the scene comes off as fun and casual.

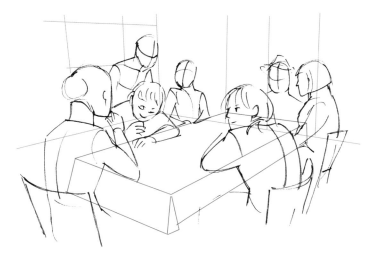

5 ADJUST POSES AND PERSPECTIVE

After choosing the angle, set up the straight lines of the room and make sure the perspective lines are properly aligned; the lines of the rectangular table should be parallel to the rectangular room it's in the middle of. Start putting more thought into the poses. Some are slouching, leaning forward or leaning back. This lets you show more of their faces and add more personality to the picture.

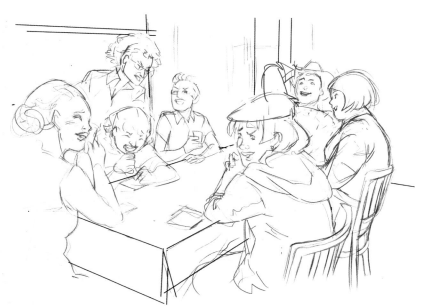

6 REFINE AND ADD DETAILS

Make a few more adjustments so you can see everyone's faces. Start adding their expressions and refining their posture more to give a better idea of their personalities. They're reacting differently to the card game and also to one another playing the game. Add more detail to the clothes, anatomy and the background.

7 CLEAN UP

Once you're satisfied with the composition, clean up the rough sketch to get it ready for inks and colors.

8 INK

Even though some characters are closer to the viewer, they're not necessarily the main characters of the shot. Everyone's expressions and clothes distinguish them, so make sure to give them detail even though they're further in the back.

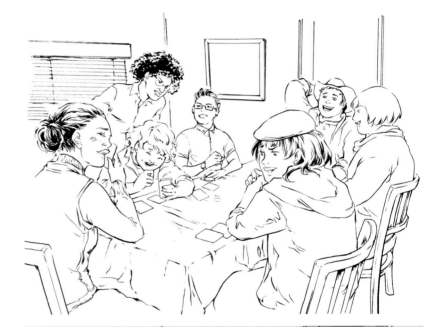

9 COLOR

Time for some colors! Put in the flat, basic colors for the characters and the background. Now you're ready to play around with lighting options.

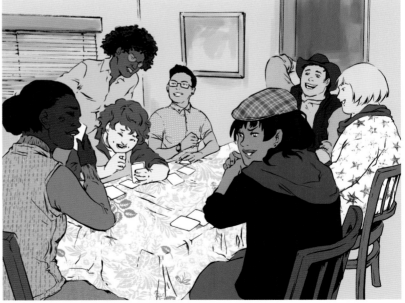

10 SET ATMOSPHERE WITH LIGHTING

Set the lighting so that you have a brightly lit scene. This makes the colors more saturated, and the event feels more fun and casual.

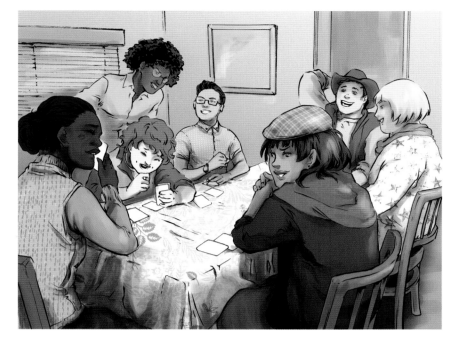

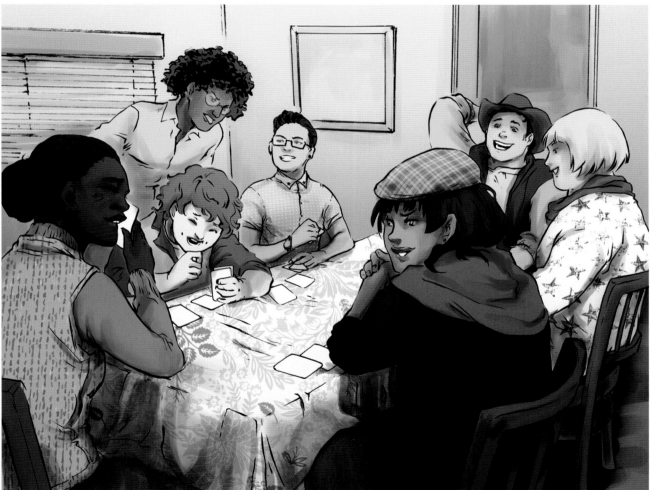

11 ADJUST LIGHTING TO FINISH

In this shot the overhead light makes the room seem smaller, and the dark gives it a sense of intimacy.

HUGGING

While hopefully your characters really have someone they can get a few hugs from, these tips can be used with any kind of character interaction. When characters are interacting, you want to make sure their bodies are to scale; that is, even if one is taller or wider than the other, relative to each other, their proportions need to be correct.

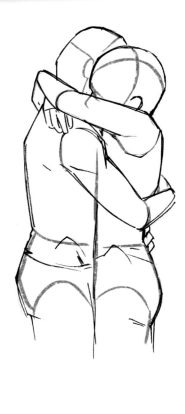

1 SKETCH THE SHAPES
Here, the bodies are a bit foreshortened due to the angle, it's most obvious on the person who is furthest away, which adds dimension to their interaction.

2 ADJUST BODY CONTOURS
Much like sitting squishes the thighs and flutes against the sitting surface, the same thing happens when next to another body.

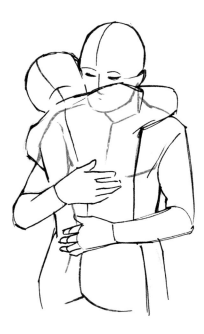
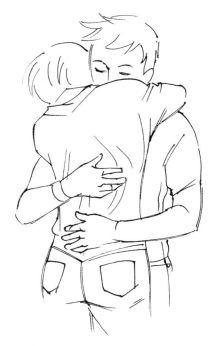

3 ADJUST PROPORTIONS

Drawing through is still important! It will help make sure you don't lose track of proportions. Here, since the person closest has an arm up over the other's shoulder, lifting them up, their backside is a bit higher than their partner's.

4 CLEAN UP AND INK

Lines on the back of the shirt make it clear the hand is really interacting with it, wrinkling the fabric in the hug.

5 COLOR

In this pose you can only see half a face. You could show all of it by changing the pose a bit, but in this case it brings attention to the drawn eyebrows. That, along with the close hug makes it obvious these two really care about each other.

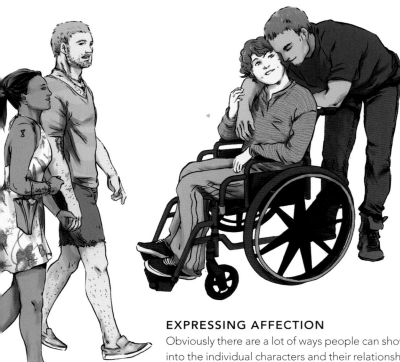

EXPRESSING AFFECTION

Obviously there are a lot of ways people can show their affection, and all those are nuanced looks both into the individual characters and their relationship! Some people express their feelings exuberantly, quietly or casually. Sometimes lovers don't hold hands while best friends do.

SKATING DATE

Let's do another detailed scene, this time with just two characters so we can focus a bit more on showing them off.

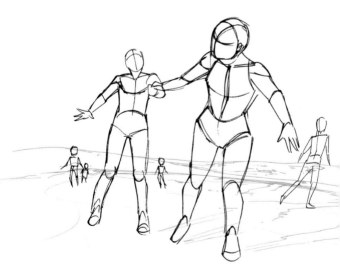

1 ROUGH IN THE SKETCH

Rough in the initial sketch idea. It's very rough, but you can tell from the gesture of expression and body language that the guy probably can't skate all that well, and the girl is pulling him along.

2 ADJUST ANGLE AND FORESHORTEN

You want the couple to be the main focus, so change the angle and foreshorten it so it looks like they are skating toward the viewer, with a bit of upward camera angle to make it more dynamic.

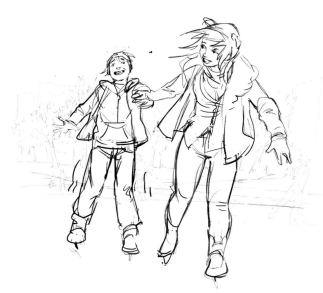

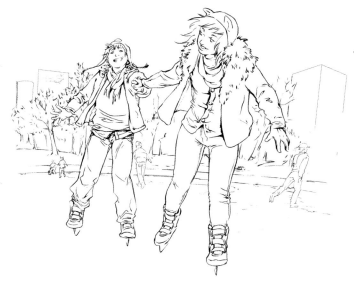

3 REFINE THE DETAILS

Fill in more detail, clothes, expressions and the background. The horizon line intersects all the skaters at their knees, which makes everyone look like they are on the same plane and unites the piece.

4 CLEAN UP AND INK

Time to ink. The lines on the two main characters are thicker and more pronounced, which makes them stand out more. The thinner lines of everything in the background provides a sense of distance.

5 COLOR

Just like the thin and thick lines provide contrast that draws the eye to the main couple, so do the colors. The lighter colors of the background make the more saturated colors of the couple really stand out! The light blues of the background also say *winter*.

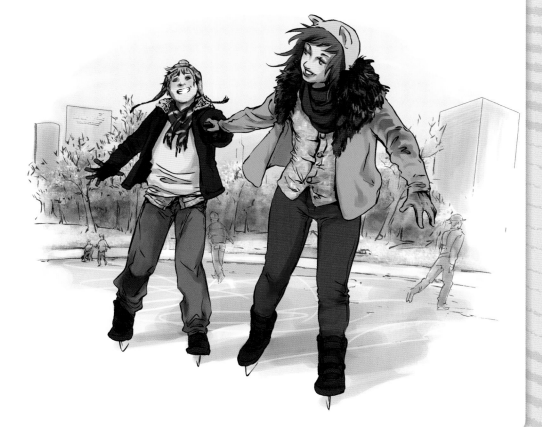

FALL DATE

With the previous date sample, I wanted the couple to be the focus, but with this one I want to show that the setting and how the characters interact with it can play a big part in the piece.

1 ROUGH IN THE SKETCH

First I sketch out my idea. The girl is walking on a different level, so I draw lines from the boy's legs so I'm sure they still line up.

2 ADJUST THE POSES

You do want him leading the way just a tiny bit, so he has to tilt his head back and up a bit to kiss her hand.

3 FLESH OUT BODY STRUCTURE, SKETCH THE CLOTHES AND BACKGROUND

Flesh out the body structures, sketching in clothes and getting a better feel for the background.

4 INK AND ADD DETAIL

You want a more painted background, so only ink in the characters and a bit of detail on the road and on the wall. This will help connect them to the background when you start painting. If the characters only had lines, it would make them seem flat against the background. Sketch out the rest of the background in blue to give yourself a loose idea of what you want to do.

5 BEGIN BUILDING COLOR

Color the characters and lay down a background color. If you do this instead of coloring directly on white, you can work that color into your painting itself, without worrying about white showing through if you miss something.

6 CONTINUE LAYERING COLOR

Do your colors in layers—a dark green for the background, then brighter fall colors on top of that for the foliage. You can see how the road and the spaces between the trees still have some of the original background color visible, and it works much better than white would.

7 ADD FINAL DETAILS

Add more leaves to the road and shift your color palette (via computer) to be more yellow and orange so that it gives a feeling of a warm fall afternoon. Draw the girl's hair and scarf fluttering in the breeze. Add the loose leaves flying in the breeze as the final touch. Some are in front of the characters and some are blurry, like moving objects in a snapshot.

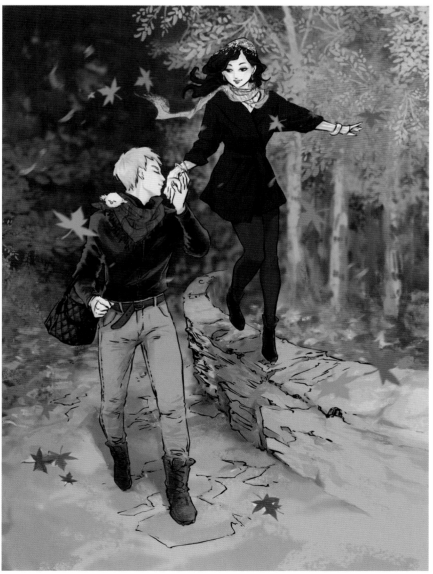

CONFRONTATION

Not all interactions are adorable and lovey-dovey! Here's a look at a tenser scene; apparently Trevor overheard this guy insulting his hat!

1 ROUGH IN THE SKETCH
With a pose like this, the characters' size difference is really obvious. The shorter one looks even smaller by being forced to tilt back. It's also obvious that the big guy has his muscles tensed up. His face is jutting forward which allows him to loom over the smaller guy even more.

2 CHOOSE THE ANGLE
Pick an angle since that clearly shows their expressions. This one is a bit humorous, thanks to the lower lip sticking out. The characters can be taking this scene very seriously while the reader knows it's nothing to stress about.

3 ADJUST ANGLE AND FORESHORTEN
Make some adjustments from the original sketch. The smaller character's hair is now slicked back, and he's wearing a polo shirt, so he looks preppy The lines next to Trevor's left fist make it clear he's trying so hard to resist hitting him that he's shaking.

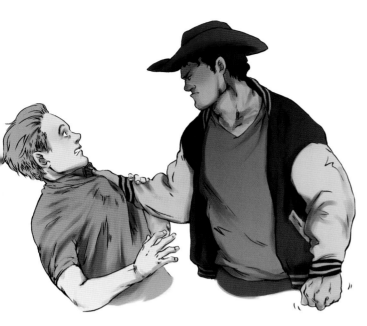

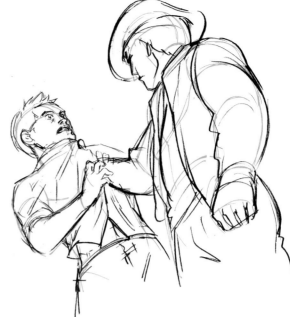

4 SHADE AND SHADOW
The hat provides an excuse to shade Trevor's face, making him look even more upset. But even with that, the pose is such a classic representation of aggression it's hard to take it too seriously.

5 ADJUST THE ANGLE
Now, if you change the angle like this, it actually looks more menacing.

6 COLOR AND ADD FINAL DETAILS
Focus is on the smaller guy's face and how freaked out he is. Trevor's face is hidden, making him more impersonal. His fist is pulled to the foreground. Use foreshortening to make it look much larger. This angle is a lot more dramatic! The angle you choose to draw a scene from really makes a difference.

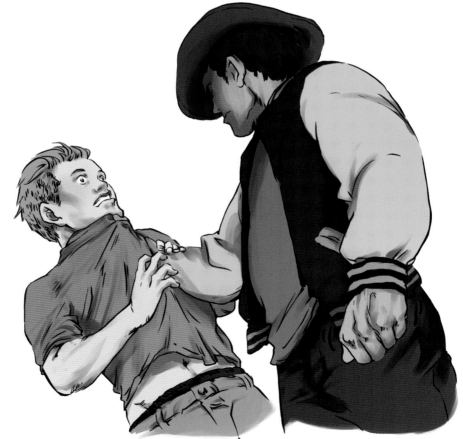

6 | Vehicles

We've talked a lot about the body types of characters and how they dress. Now let's focus on how those characters get around!

This chapter will cover many examples of different kinds of vehicles and how to draw characters inside and around them.

Personalized Transport

First, personalization! Beyond bumper stickers, you can decorate windows, grills, antenna, and just about any other part of your character's vehicle you like.

A D20 VINYL DECAL

BIKE BELL

BIKE BASKET

THUNDER GOD ANTENNA BALL

MUSTACHE DECAL

Cars

Let's focus on the motion of getting in and out of cars. If you're drawing a comic, transition shots like this are often helpful so that you don't abruptly have one scene inside a car and the next on a street block.

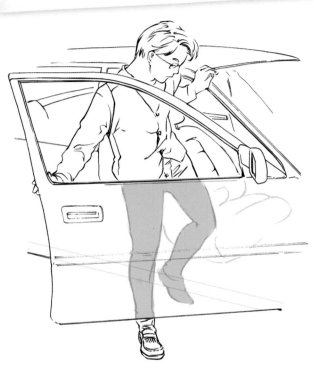

DRAWING CAR DOORS
Draw through the car door. Getting into a lot of detail isn't important, but you want to make sure the body behind the door is still in proportion.

PAY ATTENTION TO DIRECTION
People usually look toward where they're sitting when they get in the car and look out when they step out of a car.

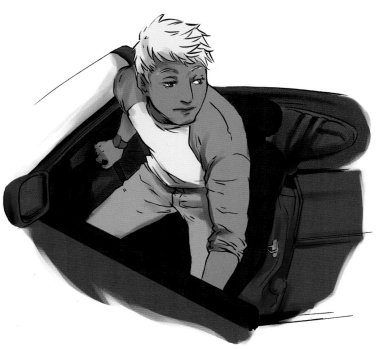

SELL A SENSE OF MOTION

That little detail really sells the motion, so that the viewer can recognize right away if someone is getting in or out of a car, even if that picture is seen entirely out of context.

VARY POSES

Cars are big and solid, so they invite a lot of interaction. Characters can hang, sit and lean on them.

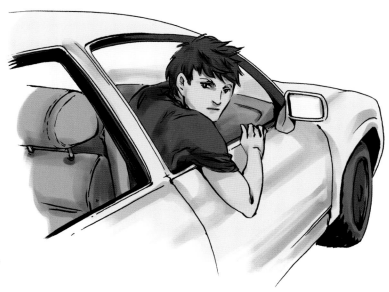

EXERCISE ARTISTIC LICENSE

When drawing characters inside a car (or any other tight space) you can use some artistic license to remove things like doors and windows that might be in the way of your shot.

RIDING IN CARS

If you are drawing characters getting in and out of cars, chances are you're going to want to draw them inside cars, too.

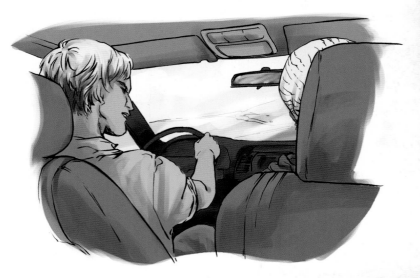

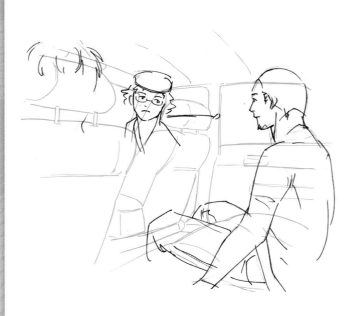

1 SKETCH THE SCENE
Choose the best angle for the interaction. The car interior is pretty solid and unmoving, so sketch that first. Then place the characters inside.

2 MAKE ADJUSTMENTS
There is some room for adjustment if you want to, since car seats can lean back a bit, and characters have some space to move around. Just keep in mind what you can play around with in your setting.

3 DETAIL AND INK

Detail! Even though you have laid out the entire interior, you only have to be detailed about whatever is visible.

4 COLOR

Add color and make any final additional details to finish.

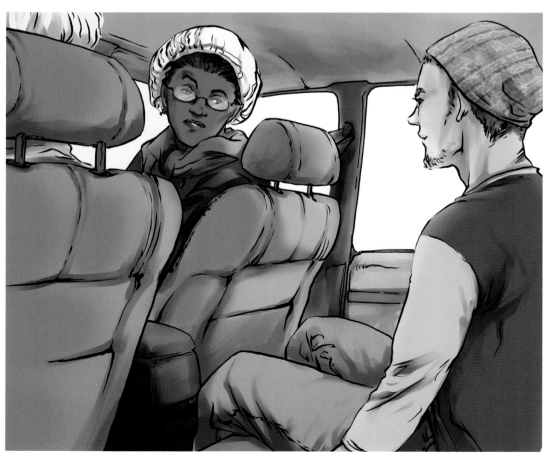

CARS IN SCENES

Follow the steps to draw a car in a scene.

1 SKETCH THE SCENE
Do all your planning in the rough sketch. The heights of the characters are 5'10" and 4'11", but Roy is wearing lifts, so let's say he's 5'2" for this shot. You want them leaning against a smart car, so ask the internet for its dimensions. You can also eyeball it from real life, but remember, you want the height to be a specific marker of how tall your characters are.

2 ROUGH IN DETAILS
The car is supposed to be 5'6" high, but use artistic license to make it a bit smaller and emphasize that it's a tiny electric car.

At this point, you should have roughed in the car details and refined the poses.

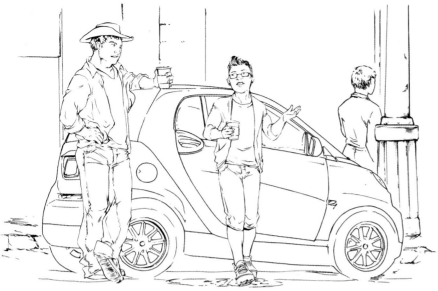

3 DETAIL AND INK

Time for details. Again, references are your friend here. But don't forget to also detail things in the background, like making sure that the column and wall don't look pristine and new.

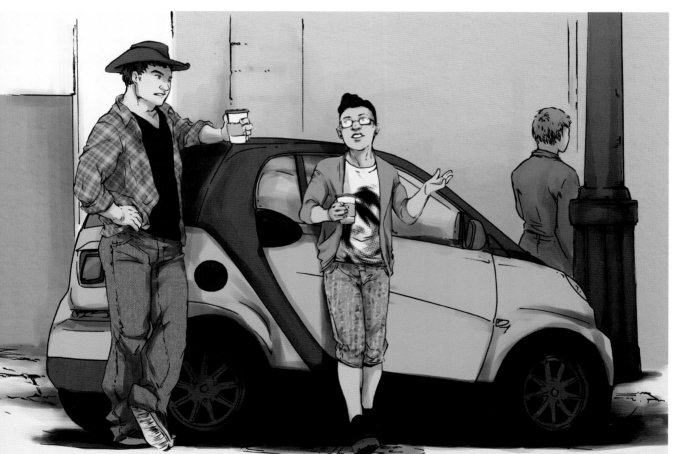

4 COLOR

Now add colors. The way the shadows are placed around the characters and against the vehicle help to show how close they are to it. This solidifies that they are really interacting with the vehicle.

Other Vehicles

There are lots of vehicles out there! If you can't find one that is perfect for your character, get a little inventive; change colors, designs, or create something unique to your story.

MOTOCROSS BIKES

ATVS

BIKES
Here's biking at some various angles. You don't have to always draw a particular bike if you don't want to, but it's best to draw various models at various angles so you get familiar with all the different parts, otherwise your bike is going to look a bit off.

MOTORCYCLES
Two different styles of motorcycles being ridden in two different ways.

SCOOTERS
Scooters aren't just for kids!

WHEELCHAIRS
Wheelchairs also come in a lot of varieties to give their users more mobility, ones for racing, basketball, tennis and more.

RIDING AN ATV

Follow the steps to draw a character riding an ATV.

1 SKETCH THE POSE
Sketch the basic pose. Again, use references, but at this stage, general shapes are fine.

2 BUILD IT UP
There's a lot of movement to this. You want the ATV to be in the air, so you can already see the fabric of the clothes being affected.

3 ADD DETAILS AND INK
Now to the details. The muscles in the arm are contracting, holding tight to the handlebars. Use small dots and lines to give the ATV imperfections, making it looks a little dirty and used. The wheels should have dirt flying off them, which lets you know they're spinning.

4 COLOR

Add color and even more detail, especially indicating more dirt on the vehicle.

5 ADD THE BACKGROUND

This is a sunny desert, so the sand is bright and the shadow of the ATV is really obvious. The background adds a sense of space and movement.

RIDING A BIKE

Bikes are a popular transport for the young trying to get around on a budget. They're also a bit less intimidating to draw than cars.

1 SKETCH THE POSE

Draw the bike first. Then draw the figure on top of it. The bike is a solid item, but the rider works around it.

2 ADD DETAILS

Start adding detail. Finish off the body outline and add clothes before doing detail on the bike. Certain parts of the bike are going to be covered up, so there's no point in detailing those areas.

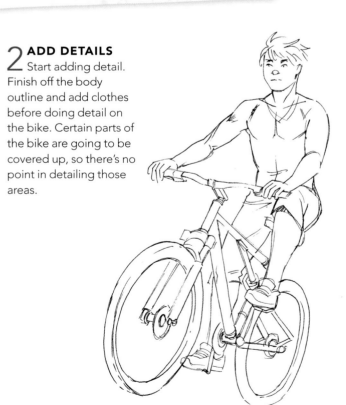

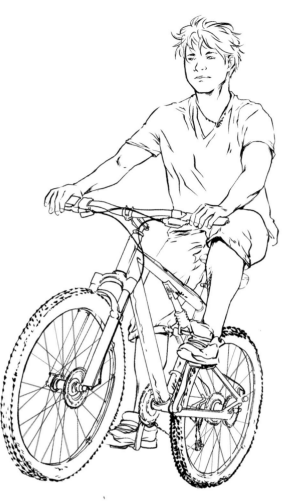

3 INK AND ADD MORE DETAILS

Use a reference for the details if you need to. Things like bikes that have a lot of parts are going to look different depending on the type of bike and brand, so it's best to just use a reference heavily if you want to be accurate.

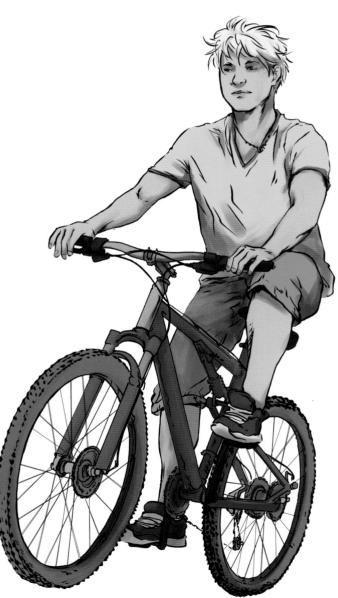

4 COLOR

Bikes come in a lot of colors and can be personalized to have an even wider variety.

RIDING ON HANDLEBARS

Riding on handlebars probably isn't the greatest idea, but they look like they're having fun.

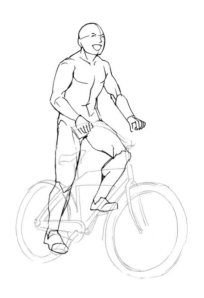 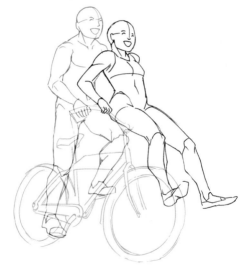

1 SKETCH THE POSE

Once again, start with the bike. Sketch quickly, but enough to set your angle and let you draw the person on top of it. If there is someone on the handlebars, he's going to need more weight on the pedals and will have to be leaning over to see over whomever is in front. So draw him standing.

2 ADD THE SECOND FIGURE

It's important that the second figure looks like she's sitting realistically; this isn't exactly comfortable. Her legs are stretch out in front to help her balance, which means she also leans back a bit. Make any necessary adjustments to the first figure; he might need to lean back more too.

3 ADD CLOTHES AND EXPRESSIONS

Now that you have the positions worked out, add clothes and facial expressions.

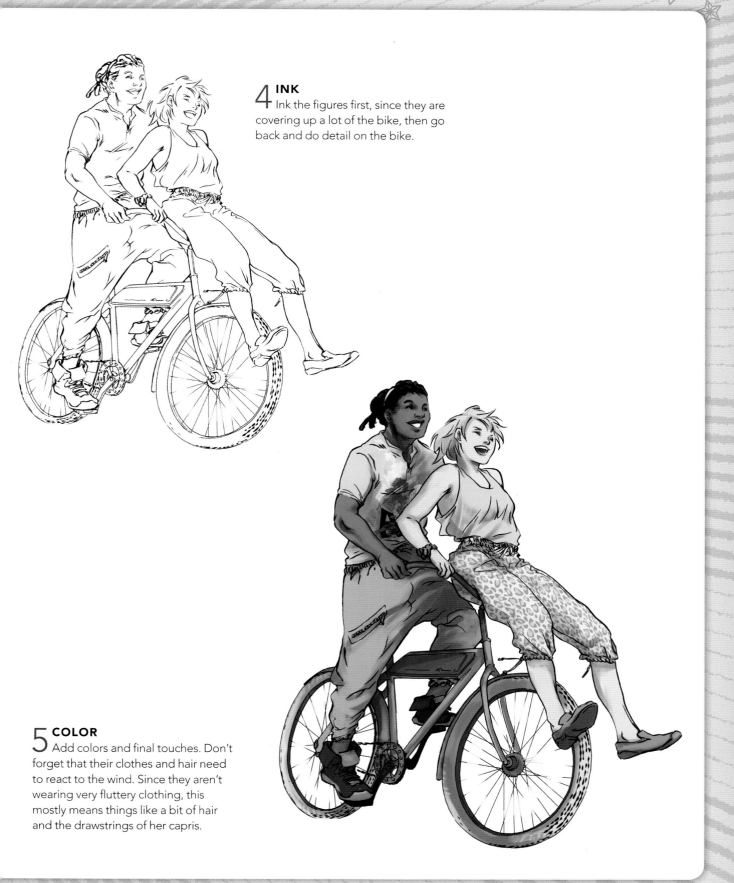

4 INK
Ink the figures first, since they are covering up a lot of the bike, then go back and do detail on the bike.

5 COLOR
Add colors and final touches. Don't forget that their clothes and hair need to react to the wind. Since they aren't wearing very fluttery clothing, this mostly means things like a bit of hair and the drawstrings of her capris.

TAILGATING SCENE

Here's another complicated group shot, this time at a tailgating party. You'll want to take your time sketching everything out just how you want it before you ink anything.

1 SKETCH THE SCENE

First set the scene with simple one-point perspective. This means all the lines are disappearing into the same point on the horizon line. Set up the vehicles first, since they will be in linear order in the parking lot. You want the sides of the vehicles to match up with the guidelines provided. This ensures they foreshorten correctly and keeps them nice and angular.

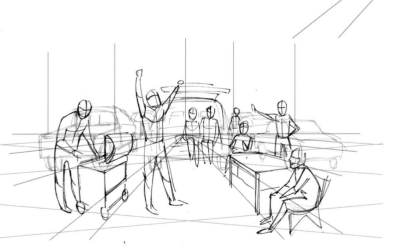

2 BUILD IT UP

Add additional guidelines to set up the angle to curve slightly on the outside, almost giving us a fish-eye view. Start sketching in the figures, spreading them across the space.

3 CLEAN UP AND ADD EXPRESSIONS

Now that everything is laid out, get rid of the guidelines and begin fixing anatomy and adding some rough expressions.

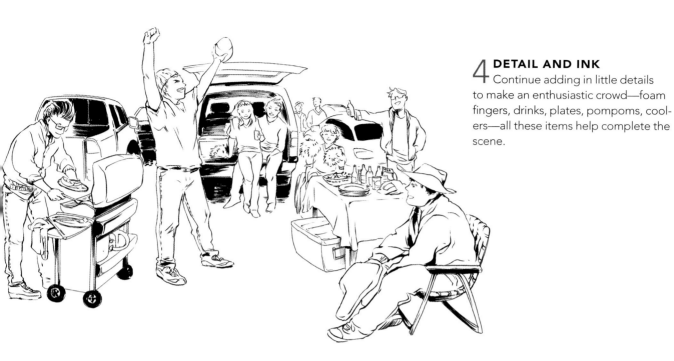

4 DETAIL AND INK
Continue adding in little details to make an enthusiastic crowd—foam fingers, drinks, plates, pompoms, coolers—all these items help complete the scene.

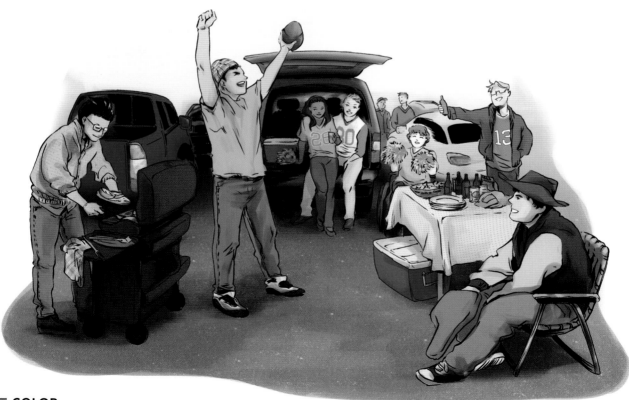

5 COLOR
Add color—it's a perfect sunny day for a pre-game tailgate party!

Index

a content + ecommerce company

Other fine IMPACT Books are available from your favorite bookstore, art supply store or online supplier. Visit our website at fwmedia.com.

18 17 16 15 14 5 4 3 2 1

DISTRIBUTED IN CANADA BY FRASER DIRECT
100 Armstrong Avenue
Georgetown, ON, Canada L7G 5S4
Tel: (905) 877-4411

DISTRIBUTED IN THE U.K. AND EUROPE
BY F&W MEDIA INTERNATIONAL LTD
Brunel House, Forde Close, Newton Abbot, TQ12 4PU, UK
Tel: (+44) 1626 323200, Fax: (+44) 1626 323319
Email: enquiries@fwmedia.com

DISTRIBUTED IN AUSTRALIA BY CAPRICORN LINK
P.O. Box 704, S. Windsor NSW, 2756 Australia
Tel: (02) 4560-1600; Fax: (02) 4577 5288
Email: books@capricornlink.com.au

ISBN 13: 9781440334726

Edited by Christina Richards
Designed by: Wendy Dunning
Production coordinated by Mark Griffin

METRIC CONVERSION CHART		
To convert	**to**	**multiply by**
Inches	Centimeters	2.54
Centimeters	Inches	0.4
Feet	Centimeters	30.5
Centimeters	Feet	0.03
Yards	Meters	0.9
Meters	Yards	1.1

About the Authors

Irene Flores is an illustrator, part-time framer, occasional author and full-time coffee drinker. Her books, *Shojo Fashion Manga Art School* and *Shojo Fashion Manga Art School, Year 2* were published by IMPACT Books in 2009 and 2012. She is the co-creator of the manga trilogy *Mark of the Succubus* with writer Ashly Raiti published by TOKYOPOP. She has also worked for DC/WildStorm, Marvel Comics, and BOOM! Studios.

Growing up in the Philippines, Irene was heavily influenced by both Japanese animation and American comics. In 1994, she and her family moved to the United States. She currently works and resides in San Luis Obispo, California. Her tumblr artblog can be found under her username, beanclam. Visit her website at beanclamchowder.com.

Krisanne McSpadden was born in Phoenix, Arizona, and after a lifelong dream of escaping now lives in Seattle, Washington, surrounded by numerous friends and an almost morally irresponsible amount of delicious food. Her passions are writing, world design, characters, and story, and her next goal is to tackle authoring her own manga. This is Krisanne's third book. She co-authored the first two books in the *Shojo Fashion Manga Art School* series. Contact Krisanne at mcspadden.k@gmail.com.

Dedication

Irene

I'd like to dedicate this book to the amazing art teachers I've had in my life, and to my family and friends for supporting me and never forcing me to "get a real job."

Krisanne

To my Seattlites, without whom I might not have starved, but at least would have enjoyed far less delicious food, friendship and happiness while trying to stake my claim in North-Western lands.

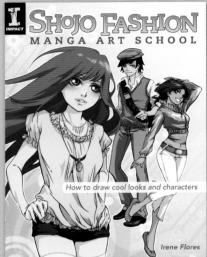
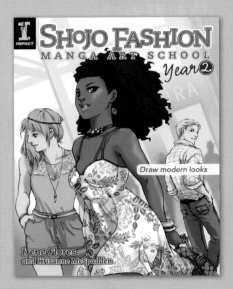